EXCELSIOR

AMUSEMENT PARK

EXCELSIOR

AMUSEMENT PARK

*Playland of
the Twin Cities*

GREG VAN GOMPEL

THE
History
PRESS

Published by The History Press
Charleston, SC
www.historypress.net

First published 2017

Manufactured in the United States

ISBN 9781467137935

Library of Congress Control Number: 2017934954

CONTENTS

FOREWORD

Fred Pearce Sr. was my father, who passed away in August 1959. I was five years old at the time, and I only have only a handful of very fleeting memories of him. Reading this book has provided me with new information about my father and helped me to form a more complete picture of the person he was.

As you will learn, Fred Pearce Sr. was best known as a builder of roller coasters and the first to use creosote-treated lumber in the construction of wooden roller coasters. He was also an entrepreneur who, in 1924, had a vision of bringing an amusement park to the shores of Excelsior Bay and Lake Minnetonka. Careful planning and hard work made his vision a reality, and the park was enjoyed by visitors for almost fifty years.

Greg Van Gompel, the author, artfully relays the story of the Excelsior Amusement Park. His thorough research and attention to detail are evident to the reader. Greg provides an accurate account of the park that was and still is an important part of the historic fabric of the city of Excelsior. In the process, he also provides a peek into the professional and personal aspects of Fred Pearce's life.

This has been a project on which Greg has worked for several years, and his commitment is truly appreciated by the descendants of Fred Pearce. Several of us have been pleased to contribute photos, information and stories that have added to the volumes of information previously compiled.

This book is a gift to the residents of the city of Excelsior and the family of Fred Pearce and will be treasured for years to come.

It provides a snapshot of a strong man with an entrepreneurial spirit who passed away (from a heart attack, not a dramatic fall from a roller coaster, as some websites proclaim) years before many of us knew him.

Thank you, Greg, for your many years of hard work and dedication to this project.

KATE PEARCE
Child no. 5 of 6

PLAYGROUND OF THE TWIN CITIES

The 1924 outdoor amusement season was quickly coming to a close, yet a well-dressed thirty-nine-year-old businessman from Detroit, who was an experienced operator and builder of outdoor amusement facilities, had come to the Twin Cities to finalize the location of his latest outdoor amusement facility. Fred Pearce had been to the Twin Cities area several times in the past looking for a place to build an amusement park, and now that it was September, he needed to make a decision in order for the park to be built and operating by the beginning of the 1925 season.

As a man knowledgeable in the history of the amusement industry, Pearce sought the Twin Cities market as a location for one of his parks for several reasons. In 1920, Minneapolis was the eighteenth-largest city in the United States, and the population of Minneapolis and St. Paul combined was greater than 600,000 people. That number of people should be able to supply enough local repeat business to support several outdoor amusement facilities. While the Twin Cities area had supported several amusement parks in the past, by 1922, only Wildwood Amusement Park was operating at that time. Wildwood was situated in Willernie on the southeast corner of White Bear Lake at the extreme northeast end of the St. Paul trolley line. A Minneapolis park location could easily establish its visitor base from Minneapolis residents without being in extreme competition with Wildwood and without any fear that Wildwood would cannibalize its visitor base.

The Twin Cities location Fred Pearce was considering was located in the village of Excelsior, and it had some considerable qualities going in its

favor to become an amusement park. Excelsior is located on the southern shore of Lake Minnetonka, which had historically been (and continues to be) one of the most populous vacation and recreation spots in the entire Twin Cities area. Lake Minnetonka is well known to Minneapolis residents, and train and trolley transportation at that time that covered the eighteen miles from the city to the lake made the lake extremely accessible. This particular location Pearce was considering sat on the east end of Excelsior on the lakeshore, at the far west end of the streetcar rails of the Minneapolis & St. Paul Suburban Railway Company and the Minnetonka and White Bear Navigation Company. The west end of this property location originally housed a terminal or dock station for ferry boats that traveled to different destinations around Lake Minnetonka and, in particular, to Big Island Park, an earlier Twin Cities amusement park that operated from 1906 to 1911. Pearce also was told that he had the possibility of utilizing a swamp on the east side of the parcel. This location seemed to offer many of the same features Pearce had utilized at the other parks he operated. If the village would approve a park on this parcel, Pearce was ready to open his Twin Cities amusement park.

Pearce had come to the Twin Cities to negotiate a lease with the Minneapolis and St. Paul Suburban Railway Company and the Minnetonka and White Bear Navigation Company for this parcel, as they were the owners of this Excelsior location. The owner, like a majority of the existing streetcar companies at that time, had always sought out ways to receive a greater economic benefit from the land located at the end of its lines. By placing what it termed "traffic generators" at the end of the line, the streetcar companies could help boost the use of the rail lines on the weekends. Streetcar lines had to pay a flat rate to the electric company each month for electricity needed to run its cars. Traffic generators—such as picnic areas, recreational areas or amusement parks—would drive additional use of the streetcars on the weekends to raise additional revenue to help pay for the electricity. To attract traffic generators, railway companies would typically lease the land at the end of its lines at low rates to the person or company that would operate the traffic generator. If an amusement park was located at the end of the line, they were usually referred to as "trolley parks." The parcel of land that the Minneapolis and St. Paul Suburban Railway Company and the Minnetonka and White Bear Navigation Company offered to lease to Pearce included 1,600 feet of lakefront, while ten of the seventeen acres of the parcel were swampland that was difficult for the railroad company to use. The parties agreed on a twenty-year lease for the property.

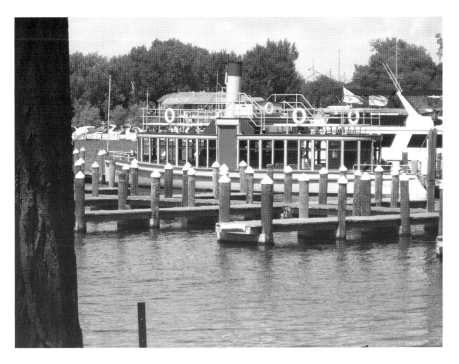

Current photo of the *Minnetonka* pleasure craft on Lake Minnetonka. *Author's private collection.*

Keeping in mind that in 1924 Pearce was planning to construct and operate what was then considered a large amusement resort, he had to think of rides and attractions that would interest people in attending his new park. Among the amusement devices Pearce was considering for his new resort included a modern-day roller coaster, a whip, a carrousel, a kittykart, a Ferris wheel, an airplane, a swing and an old mill. Several concession buildings, a sunken garden and an overhead bridge of rams leading over the Yellowstone trail to a pavilion with a view of the lake were also included. These ideas and attractions were also part of Pearce's initial proposal. Pearce estimated that he needed to invest about $200,000 in buildings and equipment to make his proposed plan come to life.

On September 24, 1924, the citizens and residents of the village of Excelsior submitted a petition to the village board expressly approving the proposed plan of Fred W. Pearce & Company to construct an amusement park on that seventeen acres of land. The project was approved by the Excelsior Village Board that same day. Pearce estimated that the amusement park would bring 1 million additional visitors to Excelsior in 1925, half of

whom would come by trolley and the other half by auto. The name that he chose to call his proposed park was Excelsior Park.

Just as construction was about to begin on Excelsior Park, Fred Pearce was scheduled to give a speech at the Drake Hotel in Chicago as a part of the 1924 National Association of Amusement Parks (NAAP) convention. The NAAP holds an annual convention at which all the owners, concessionaires and manufacturers gather to discuss the business of the outdoor amusement industry. The speech Pearce gave on December 5, 1924, was entitled "Free Gate or Pay Gate." Based off his speech, in which Pearce laid out his argument for why he thought using free gates for an amusement park was a better business model than a pay gate, one could easily guess that Excelsior Park would also be a free gate park.

In his speech to the NAAP, Pearce stated that advocates of the pay gate say that the gate keeps out the rowdies. He questioned whether the advocates meant to infer that rowdies are all paupers. Pearce countered that contention, stating that it was his experience that the so-called rowdies are young men with pockets full of money and that they are very apt to be rich men's sons as well as the sons of poorer families. He stated that if these rowdies wanted to go into a park, no ten-cent admission is going to stop them.

He also stated that advocates of admission-charging parks say that the charge adds dignity to their park. To Pearce, such a claim is ridiculous, for he could not stretch his imagination so far as to think that a ten-cent admission ever dignified any place. He said that the free park is the one with the strongest appeal. The park that throws its gates open and hangs up a welcome sign is the park that will do the business, according to Pearce. He advocated to "let the people in and let them spend their money where they like and don't try to charge admission and cram down their throats free entertainment that they don't care for." Pearce said that advocates of paid gates call your attention to the revenue derived from the gate, but they fail to take into consideration the enormous amount of money their concessionaires are losing. The percentage admission-charging parks receive from the revenue that concessionaires would generate would make their gate receipts from admissions small by comparison. Besides, he said, those advocates for charging admission lose sight of the advertising value of having a crowd in their parks. Pearce believed it is a human weakness to want to go whenever there is a crowd. Pearce used the analogy of a theater to prove his point. "Did you ever pass a theater with the 'Standing Room Only' sign hung out that you didn't want to see the show yourself? The mere fact that you knew the theater or show was full would be sufficient recommendation

for a customer to want to see that show." For these reasons, Pearce opined that the free gate park had arrived.

Just two days later, construction for Excelsior Park commenced. After the first month of construction, residents could see the signs of how large this amusement resort was going to be. The project stretched from an area west of the dock station all the way to the start of St. Alban's Bay. Fred Pearce's first cousin, Frederick W. (Bill) Clapp, twenty-five, was hired as the assistant superintendent and paymaster for this project and would become the assistant manager in charge of pay when the park opened. Bill Clapp had lived with Fred's brother, Eugene, for more than ten years. He was both loyal to and trusted by Fred Pearce to dutifully account for the park's construction and operation. The general superintendent for Fred W. Pearce & Company, Lorenzo C. (L.C.) Addison, was at the project to give general overall direction to the park's construction. Addison, who had previously managed Pleasure Beach in Bridgeport, Connecticut, was later named the Excelsior Park's first general manager. He was in charge of building the park, as well as selecting and organizing a large workforce for the project.

Since ten of the park's acres were swampland, the construction of the park presented a most unusual construction challenge to Pearce. He would need to build all the park's rides on pilings and then fill in solid ground around the pilings. Hundreds of piles had to be driven into the swamp for the foundation of the roller coaster and large buildings. Some of the pilings

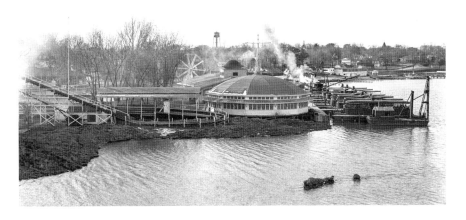

East end of the park as it looked in 1925. *Pearce Family Photographs, used with permission.*

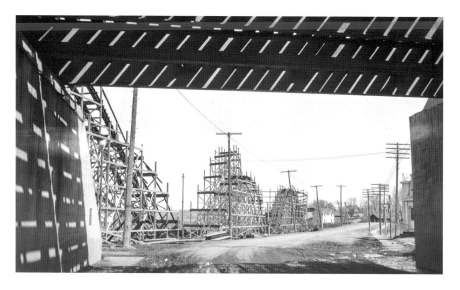

A look at the construction of the roller coaster through the railway tunnel. *Pearce Family Photographs, used with permission.*

went as deep as fifty feet. Pearce turned to his longtime engineer, Vernon Keenan, to ensure that the pilings and related structures were structurally sound. Keenan, on "loan" from John A. Miller, had been chief engineer of construction for Fred W. Pearce & Company as far back as Pearce's famous "Trip Thru the Clouds" roller coaster in Detroit in 1914, and he would later become internationally famous as the designer of the Coney Island Cyclone in Brooklyn, New York.

In his review of the parcel, Pearce decided that he would keep at least two of the buildings that he saw standing on the site. The terminal station for the ferryboats on the western side of the property was a sound building with a distinctive cupola on top from which a boat dispatcher could have a better view of approaching trains and trolleys. From a practical standpoint, the building was large enough to be either a restaurant or a home for newer amusement attractions such as the dark ride or Skooters or Dodgems, both of which were electrically charged low-powered compact vehicles used to dodge or bump other riders. The other building, a sizeable old boathouse, was on the east side of the property, seemingly poised to drop into the water that was at its edge. With its proximity to the area that was large enough to place his trademark roller coaster, Pearce needed a place where the park could house its maintenance shop. This building also housed the park's main offices. During the first years of the park, the main

office was so close to the water that Bill Clapp said on several occasions he was tempted to cast a fishing line out of his office window. Pearce thought that with capable workmen and any luck with the Minneapolis weather and shipments, his crew could have the rides ready for a grand opening by the following summer. If the opening season's business was encouraging, Pearce said that his company would ultimately increase its investment in Excelsior Park to $500,000.

In January 1925, Fred Pearce traveled to Minneapolis, spending a number of days there confirming plans for his park. Imagine, if you will, what Fred saw when he visited the park site. In the middle of a Minnesota winter, a group of men with a team of heavy horses are building a wooden roller coaster. The crew would have either a heavy-duty rope or flexible wire. Several men and horses were on the ground, while at least one man would help guide a set of constructed wooden framework into place. There were some men on each side of the frame to assist in putting the framework into its proper place The rope or wire was attached to the frame. The men lying on top of a wooden structure and a group of men and horses on the ground would slowly pull the rope or wire through the pulley or pulleys in order to lift the frame upright. The frame was lifted into place, and then a group of men on the structure and on the ground would secure the frame in its place. While this framework erection is happening, imagine another group

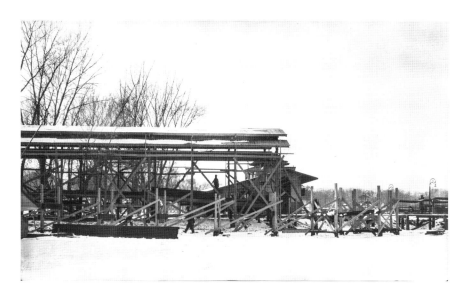

Roller coaster construction work on the ice. *Pearce Family Photographs, used with permission.*

of workers assembling the next frame to be erected. This picture gives you a great glimpse into how Fred Pearce and his business worked in building roller coasters, including the one at Excelsior.

Besides the roller coaster that was already in the process of being erected, Pearce was refining his vision of what rides he wanted for the park. He knew that he wanted Skooters for his park. Skooters and Dodgems were a new thrill device for parks in 1924, and an amusement trade publication at that time claimed that the attraction was the Rolls-Royce of amusement devices, bringing back riders again and again. (Skooters were a type of bumper cars created by the Lusse brothers, while Dodgems were innovated by Max and Harold Stoehrer.) Another novel amusement device Pearce was going to add was Custer Cars, a device patented in 1919 meant for adults and children that was a battery-powered vehicle like a car that could be driven around a designed course, the forerunner to today's antique cars. Of course, his new park had to include a brand-new carrousel, with an improved design that would attract riders of all ages. Common for parks over the previous twenty years had been airplanes or aerial swings, both rides that appealed to a human's innate need to fly. The swings would have six cars that seated four people each. These cars were attached to a 70-foot-high steel tower. The steel tower would begin to spin, causing the

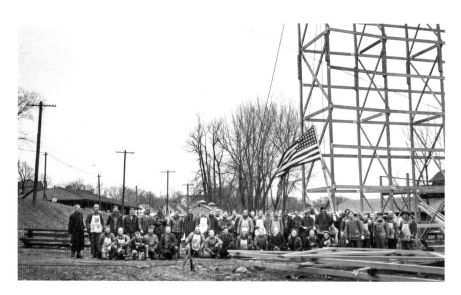

A picture of the Excelsior Park construction crew. *Pearce Family Photographs, used with permission.*

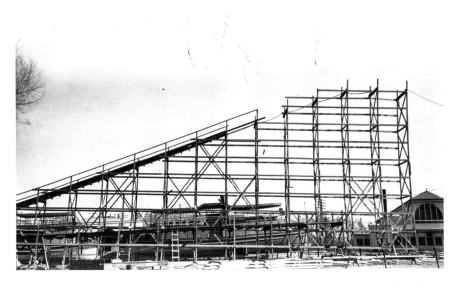

Roller coaster in mid-construction. Note the wire or rope the crew used to lift sections into place. *Pearce Family Photographs, used with permission.*

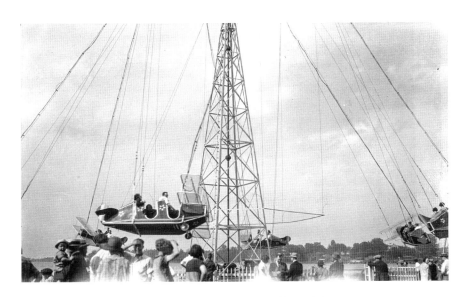

The park's aerial swings. *Pearce Family Photographs, used with permission.*

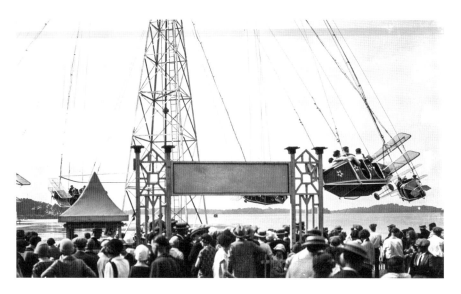

The aerial swings swung out over Lake Minnetonka. *Pearce Family Photographs, used with permission.*

cars to swing outward from the steel tower. At top speeds, the circle would reach 150 feet.

The park would also feature a new design of the miniature railway together with the newest of all park rides, the Caterpillar. Of course, the park would include the ever-popular Ferris wheel, but one that would include a new design of the ride by the Kansas-based C.W. Parker Company that had enclosed cabs. Other features that would be included in the park would be picnic pavilions, skee ball alleys (a game staple at most amusement parks even today), a shooting gallery and other skill games.

By early April, the steel tracks for a different type of miniature railway had arrived at the park. The Excelsior Park train was going to be different from others operating at that time because it would be powered by electricity and not steam. This difference would benefit the many children who would ride the train because it wouldn't produce any dust, smoke or cinders like on trains run by steam engines. The train's tracks were placed alongside and underneath the north side of the roller coaster's lift hill, the side closest to the lake.

Shortly after the train tracks arrived, the construction of the carrousel building was completed and ready to cover the beautiful horses and chariots that would soon delight people of all ages. The circular carrousel building, made of eighteen different designed parts, including some of quality lattice work, was specifically designed for the Excelsior carrousel by the infamous

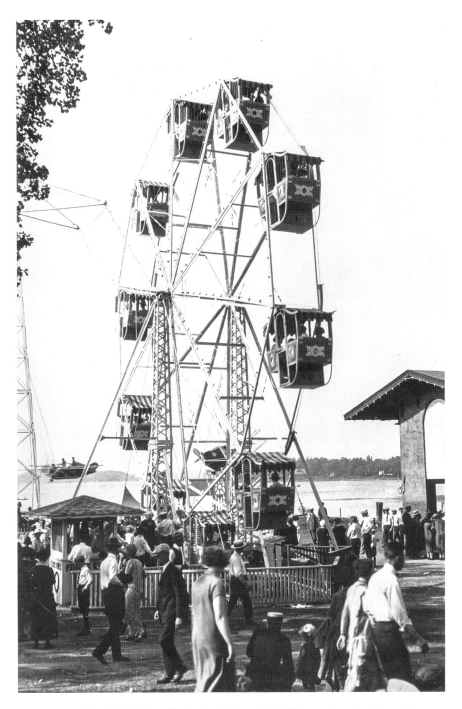

The park's original C.W. Parker Ferris wheel. *Pearce Family Photographs, used with permission.*

park engineer John A. Miller. The eighty-five-foot-diameter round building was painted a satin white and had a brilliant red roof for its top. During its first season, the northern edge of the carrousel building projected out over the water. The ornate carrousel erected inside the building was a newly hand-carved, hand-painted ride by the Philadelphia Toboggan Company (PTC), a world-renowned carrousel and roller coaster company. It is widely believed that a number of the carrousel animals on the ride may have been carved by master carver Frank Carretta, who won many prizes for his originality and perfection of his animals. Pearce's cost for the new carrousel was $12,500, and that sum most likely included the cost of a workman whom PTC would have sent to properly assemble the carrousel at the park.

This new PTC carrousel was a three-abreast wooden carrousel with forty-two horses and two gorgeous chariots, and when it opened, it included a brass ring dispenser. The outside row of horses on the carrousel was designed to be stationary so that riders could attempt to grab a brass ring from the dispenser. Much like the knights of the Middle Ages who jousted using a ring as a target, carrousel riders in the early 1900s enjoyed partaking in the popular activity of grabbing rings out of a dispenser while riding. The brass ring dispenser was suspended over riders at a certain spot on the carrousel. Either before or during the ride, rings are fed into the dispenser and held by spring-loaded fingers, allowing riders the opportunity to slip their fingers

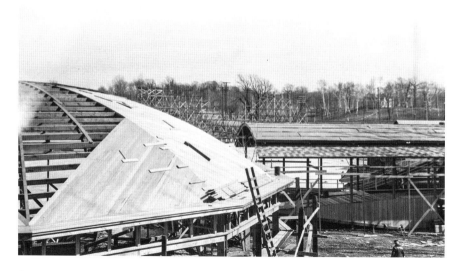

Carrousel building and roller coaster under construction. *Pearce Family Photographs, used with permission.*

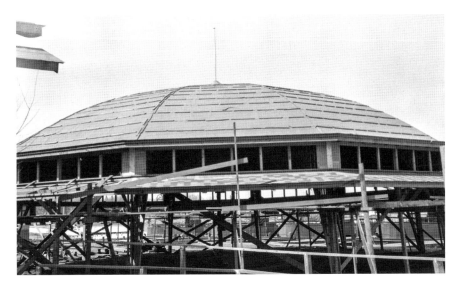

Looking at the lake through the unfinished bottom of the carrousel building. *Pearce Family Photographs, used with permission.*

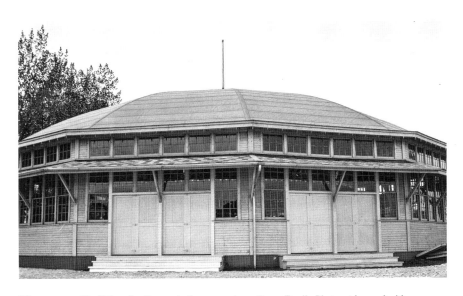

The carrousel building finally ready for operation. *Pearce Family Photographs, used with permission.*

through the center of the ring to pull out the ring from the dispenser. While the dispenser is filled with both steel and brass rings, the object of the activity is to grab either the only or one of a small number of brass rings from the dispenser. Typically, by grabbing the brass ring, a rider would get a free repeat ride on the carousel.

Carousel operators typically use music machines known as band organs to not only attract riders but also provide uplifting music for those on the ride. The band organ for the Excelsior carousel was made by Artizan (Band Organs) Company, located in North Tonawanda, New York. The city of North Tonawanda, located just outside Buffalo, was the epicenter for the carousel industry at that time, and its history is well preserved today in large measure due to the Herschell Carousel Factory Museum in North Tonawanda. The music for the Artizan organ was supplied by a double set of paper rolls that look much like an old-fashioned player piano roll. Holes that are hand-punched on the rolls drive the winds for the organ's pipes, the movement of the organ's crashing cymbals and the beat of the bass drum.

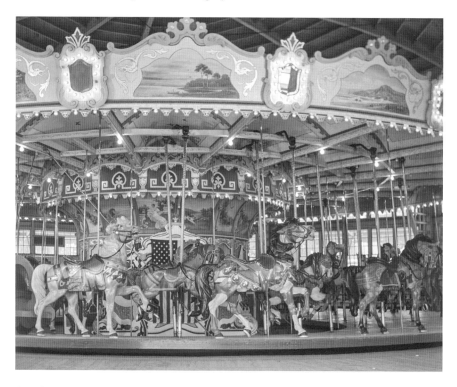

A peek at the carousel inside its new house. *Pearce Family Photographs, used with permission.*

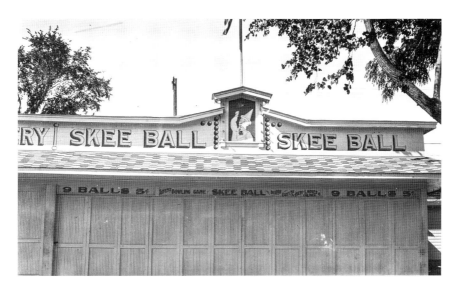

The skee ball game building at Excelsior Park. *Pearce Family Photographs, used with permission.*

John Philip Sousa marches and band organ waltzes were featured on the carrousel's music rolls.

By the beginning of May, the carrousel, roller coaster and Skooters were ready for operation. The miniature train, skee ball alleys and a number of the stands were expected to be completed soon, and the park was still waiting for the arrival of the airplane swings and Caterpillar ride. In the span of five months, Pearce was able to build his amusement park and have it ready for its opening. Just how did he make it happen? He utilized the help of the good people of Minneapolis, Excelsior and the surrounding communities. Once the weather conditions in the winter of 1925 started to get warmer, Pearce hired a very large crew of local men to erect the rides and stands for Excelsior Park, including Lloyd Mann and his team of heavy horses. Unlike today's building standards, Pearce's construction team didn't have to worry about water and sanitary sewer lines and other wholesale site preparation that you might see if a new park were erected today. Likewise, due to the type of transportation that would be used by guests arriving at the park, a minimal amount of land needed to be cleared for parking spots, and what land that was set aside for parking wouldn't require any paving. Also, by utilizing some of the buildings that were already on the park property, Pearce spent less time constructing the buildings he needed to make the park operational.

The new Excelsior Park officially opened for business on Saturday, May 23, 1925. A crowd of about twenty thousand people attended to partake in the park's eleven main attractions. Many of the park's rides and attractions had already been operating the weekend before the park officially opened, typically called a "soft opening," so that the park has a better idea of how smoothly the operations would run when it officially opened for business. By the time the park opened, the old streetcar depot, which was purchased in January 1925, had been converted into a place that housed both the skooter ride and a restaurant. According to an article in a *Billboard* publication, a magazine that wrote about the amusement industry for 111 years, Fred Pearce spent nearly $400,000 to purchase the original rides at Excelsior Park.

When Excelsior Park opened, the United States was in the middle of the Prohibition years. With the absence of inebriated visitors, neighboring residents really were not concerned about any nuisance or obnoxious behavior coming from park guests outside of the noise that thrilled patrons made while enjoying the rides at the park. Besides, residents had already become accustomed to music provided by the bands playing in the big dance hall across from the park for several years before the park opened. Prohibition lasted until 1933.

As a part of being next to the waters of Lake Minnetonka and it being a facility leased from the trolley company, Excelsior Park offered the trolley company an opportunity to keep the trolley boats operating on Lake Minnetonka. At first, the trolley company was going to discontinue the boats, but it made sense for the company to continue the boat service as another means of transporting patrons, especially during the weekend. The park also offered patrons a boat tour of Lake Minnetonka at a price of fifty cents for an adult and twenty-five cents for children. After opening, the park began to offer rides on the latest speedboats and kept a stable of speedboats moored near the park.

Early on Monday morning, June 29, 1925, just one month after the park opened, it became a target of cracksmen who used nitroglycerin to blow open the thick, steel-doored safe at the park offices. The robbers fled with the park's Sunday's receipts of $7,000, leaving nearly $2,000 in small change scattered about the floor. Attempts to photograph the fingerprints on the safe proved futile, as the robbers had used rubber gloves. The thieves left behind some of the tools used to perform the heist, including a carpenter's wrecking bar, a two-pound hammer and a four-foot crowbar. They gained access to the office by jimmying open a small window on the east side of the building by the lake. The blast tore apart both safe doors. The night

The old loading dock building from the Railway Company proved an excellent structure to house a café and the Skooters. *Pearce Family Photographs, used with permission.*

watchman, Martin Baker, who worked for the Street Railway Company, told police that he heard a blast around 2:30 a.m. but thought it was just kids shooting off fireworks and paid no further attention to the noise. A boat engineer and an owner of an all-night restaurant in town also heard the blast. The restaurant owner said that he saw a car parked outside the dance hall around 2:00 a.m. that morning, but the robbers were never caught.

While Excelsior Park opened in 1925, the park that year was still a far ways away from meeting the vision that Fred Pearce had for the property. So, right after the park's first season ended, the Pearce Company decided to fill in more of the swamp in Excelsior Bay that surrounded the park to make space for additional parking and picnic grounds. This dredging decision didn't find favor with at least some people in the community, as on October 6, 1925, an injunction was issued to stop Captain John R. Johnson and his dredging crew from taking soil from the bottom of the lake and filling in the swampy area on the lake side of the roller coaster. Shortly after the injunction was issued, a hearing was held at which many residents of Excelsior testified, and on October 20, the park's dredging and filling operation was allowed to continue. These dredging operations added several more acres to the park, allowing the park to continue to develop additional property. Since the park was still in its honeymoon period, all Addison and his management

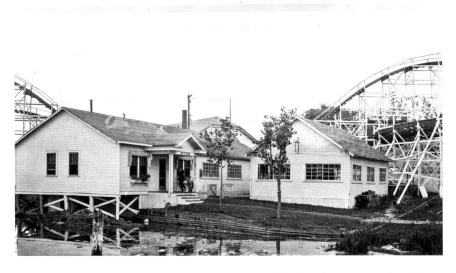

The park's office was placed in a building that already existed on the property prior to its construction. *Pearce Family Photographs, used with permission.*

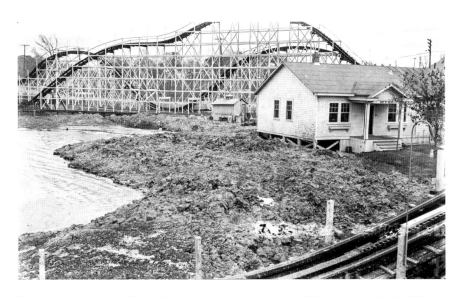

The fill surrounds the office as the park continues to acquire additional shoreline in 1926. *Pearce Family Photographs, used with permission.*

team—including F.W. Clapp Jr., assistant manager; Harold Bricker, picnic and general promotions person; and Vernon Keenan, chief engineer—did to prepare the park for the 1926 season was to tidy up the park before its opening on May 16.

The park's first substantial changes occurred for the 1927 season. A pivotal move for the park would be a picnic pavilion. After a full season of letting the dredged soil settle into its new home, the park management staff set out to construct a new picnic pavilion on the site to help entice people to have picnics at the park. Even today, the ability to host sizeable picnic gatherings at an amusement park remains a crucial part of a park's operating plan. This particular picnic pavilion at Excelsior Park sat 1,500 people at a number of tables and offered park patrons ice water and electric lights. The pavilion was also equipped with an up-to-date sound system. Just like the carrousel building, the picnic pavilion included lattice work and was designed by John Miller.

Excelsior Park also introduced the Funhouse to the Twin Cities in 1927. The Funhouse was an entire building of stunts and gags that most park visitors could enjoy. One of the main attractions of the Funhouse was the Giant Slide, a long slide made of wood. Other stunts in the Funhouse contained a human roulette wheel, a revolving barrel, a moving stairway and various other stunts. Much like a roulette wheel you would see at a casino, the human

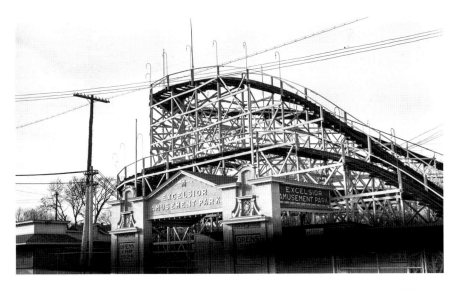

The park's east entrance as it looked in 1926. *Pearce Family Photographs, used with permission.*

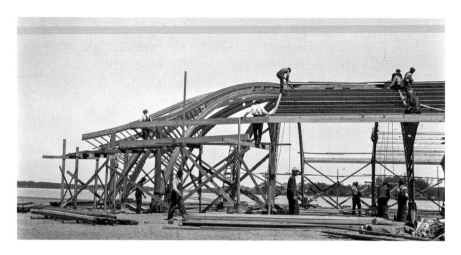

Building the John Miller–designed Picnic Pavilion in 1927. *Pearce Family Photographs, used with permission.*

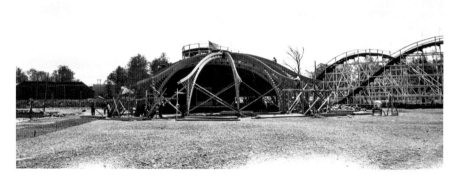

The picnic pavilion was built on the fill from Lake Minnetonka. *Pearce Family Photographs, used with permission.*

roulette wheel has humans replacing the balls. People would gather in the middle of the wheel, and once they were situated, the operator would start the wheel. Shortly after the spinning began, humans would begin sliding out of the center of the wheel to the ride's edge. Many times, participants who could no longer control their action would uncontrollably end up at the ride's edge, often being hurled into other participants. With today's

litigious society, it might be easy to imagine why most of these attractions no longer operate in the United States. The rotating barrel was a wooden barrel approximately eight feet in length with each end removed. Funhouse visitors would attempt to walk from one side of the barrel to the other end without falling down. The occasional patron would outstretch their arms and do a full rotation or more attached to the barrel. The Funhouse was a wonderful place where children could spend countless hours entertaining themselves, allowing moms time to catch up on all the latest social news. Also new for the 1927 season was the hiring of Samuel Benjamin, an experienced park manager who had spent twenty-five years as a park manager in Kansas City, Missouri, before arriving at Excelsior.

Despite adverse weather conditions, business at Excelsior Park was very good for the 1927 season. Toward the end of the season, the park held a corn festival that was well attended. For the festival, the park was beautifully decorated with stringers of colored lights and other ornaments. The initial advertised closing of the 1927 season was actually postponed, and the park stayed open later into the fall season due to a sudden spell of unusually warm weather. The park's closing this season was marked by a special program of fireworks and a naval battle.

The park's most popular attraction from the day it opened until the day it closed was its roller coaster. For that reason, it is little wonder why the roller coaster is commonly referred to as the "King of the Midway." An early

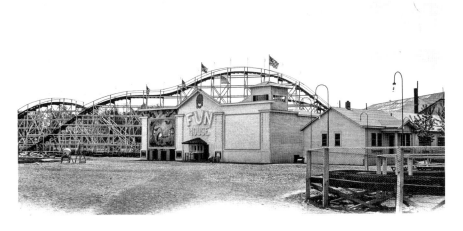

An early picture of the park's funhouse. *Pearce Family Photographs, used with permission.*

picture of the park shows that the ride had the words "Mountain Railway" on the side of the ride's station, but all of the park's brochures seem to refer to the ride as Roller Coaster. Excelsior's roller coaster was designed by Pearce's friend John Miller, a prolific and well-known designer of roller coasters and amusement park buildings. The coaster track was half a mile in length and reached a height of sixty-five feet. Its dips were as steep as any roller coaster that existed in 1925. It cost Pearce $60,000 to build the wooden coaster. Each spring, a crew of men inspected, tested, repaired and replaced parts of the roller coaster to make sure that it remained a sound and safe ride.

The Excelsior roller coaster met its first test from the harsh Minnesota weather in August 1928. Around 4:00 p.m. on Wednesday, August 1, 1928, a heavy black cloud came up in the western sky rising above Lake Minnetonka, and soon darkness spread over the entire region. A furious storm with high winds came racing toward Excelsior and hit it with full force. The force of the storm was just about equal to a tornado, and it lasted about fifteen minutes. After the high winds moved on, the rain continued intermittently for the rest of the day. A hydroplane that was moored at the Excelsior Amusement Park was picked up and deposited on the roof and side of the park's picnic pavilion, entirely wrecking the hydroplane. Several devices at the park were damaged, but the greatest damage at the park happened to the roller coaster. The wind had a taken a section of the roller coaster, picked it up and spilled the section of the coaster on its side directly onto the road next to the park. Since the roller coaster was the most popular ride in the park and a weekend was coming soon, the park gathered a large crew of workers early the next morning to begin repairs on the ride. In less than three days, this large crew of workers completed the enormous task of rebuilding the section of roller coaster, and by 9:45 p.m. Saturday night, the roller coaster was again carrying passengers on its tracks.

Later in the fall of 1928, the Pearce Company purchased from J.E. McNiece the dance pavilion, also called the ballroom, located across the street from the park. Pearce had the ballroom redecorated both inside and out for the 1929 season. The park hired a ten-piece orchestra, Red Clark and His Play Boys, to play at the ballroom for the entire 1929 season.

On November 2, 1928, the Minnesota Supreme Court decided the case of *Asplind v. Fred W. Pearce Corp.* (175 Minn. 445, 221 NW 679). In that case, Grace H. Asplind alleged that she suffered an injury to her back at or near the first descent of the Excelsior Park roller coaster when she rode it on May 23, 1926. She alleged that she was violently thrown down and back against

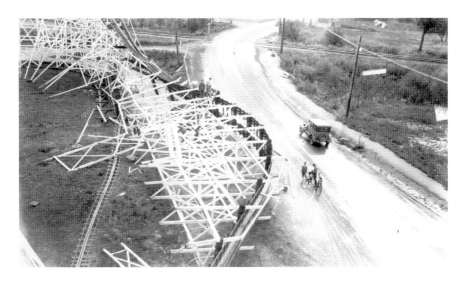

Another view of the destruction of the roller coaster from the August 1928 storm. *Excelsior–Lake Minnetonka Historical Society, used with permission.*

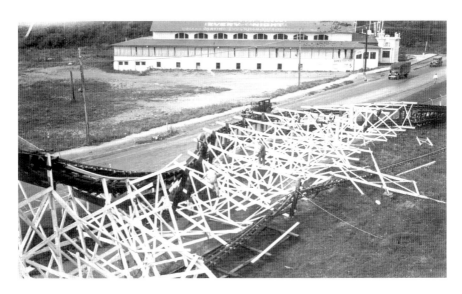

The roller coaster and a part of the train ride were tipped on their sides from a horrendous storm on August 1, 1928. *Excelsior–Lake Minnetonka Historical Society, used with permission.*

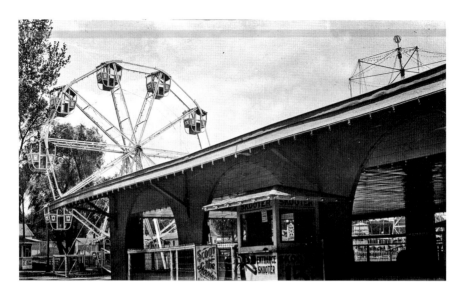

Entrance to the bumper cars located in the dock building. *Pearce Family Photographs, used with permission.*

her seat and suffered the injury. She claimed that the park was negligent in operating the car at such rate of speed at about fifty miles per hour, causing the car to jerk. The court limited the issue of negligence to whether a loose handrail provided to the plaintiff to use was in such a condition as to permit it to move and whether it was defective and the proximate cause for the injury. The court's finding noted that it permitted the evidence of other accidents with the coaster. The final outcome of the case is unknown, as it was never stated in the court's opinion.

The land under the park was purchased from Twin City Rapid Transit Company (TCRT) by the Excelsior Park Company Inc. in the 1930s along with other land and property. Land adjoining the park was purchased by the Pearce interests in 1937. In 1941, the land under the former streetcar depot and dock station (the Silver Dollar Café) was purchased from the TCRT.

In keeping Excelsior Park on the forefront of new, exciting rides, the park was home to one of the rarest amusement rides ever: the Swooper. At last count, no more than twenty of these rides were ever built. The Swooper was built by Sellner Manufacturing, a manufacturing company based in Faribault, Minnesota, and still known worldwide for its iconic Tilt-A-Whirl rides. The Swooper had an elongated, oval structure that ran parallel to the ground. Rather than a turning wheel like the Ferris wheel, the Swooper had a stationary framework. The Swooper had fifteen

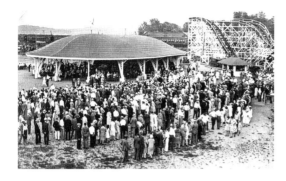

Left: People line up for a picnic at the park. *Pearce Family Photographs, used with permission.*

Below: An early picture of the Wyer-Pearce House. *Pearce Family Photographs, used with permission.*

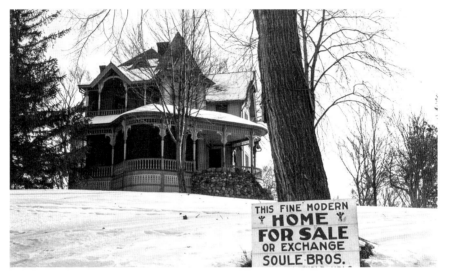

two-seat tubs, each attached to radial arms (stilt supports) that were pulled around a massive oval framework by a pair of cables. These stilts held the tubs some distance (estimate of about two meters) away from the oval, which remained stationary in a horizontal position.

The Swooper's oval structure was similar to a modern Zipper, only shorter, and it was high enough above the ride's base for the tubs to swoop down under it to near ground level. Because of the oval shape, four tubs could be loaded at once. This gave the Swooper a definite advantage over most Ferris wheels, whose revenue producing capacity has been limited by having to load one seat at a time. The Swooper was a great name for the ride, as passengers were swooped upward as they were carried to the top of the ride and experienced a second swoop as they were carried downward at the other end. The biggest thrill for the passengers came as they rounded the curved ends of the Swooper.

In 1930, Fred W. Pearce & Company acquired the Wyer-Pearce House from the streetcar company. The magnificent Victorian home dates back to 1887 and is built in an ornate style that has been described as Steamboat Gothic. It originally had twelve rooms, six fireplaces, two enormous porches, gas lighting, a vegetable garden, an orchard and a vineyard. After Pearce acquired the house, he converted it into a duplex for himself and his two park managers, Fred Clapp and Joe Colihan. The Wyer-Pearce House was used as a residence by park managers and remained with the Pearces for the entire time the park remained in operation.

THE LIFE OF EXCELSIOR PARK'S FOUNDER

Excelsior Park was the brainchild of Fred W. Pearce, whose offices from the time the park was built until he passed away remained in Detroit, Michigan. Fred was an experienced outdoor amusement businessman who touched the amusement industry from sea to shining sea, but it's difficult to uncover the total number of the projects in which Pearce was involved. He was dubbed "Mr. Roller Coaster" because he built a large number of roller coasters throughout the United States. Heck, even his extended family to this day continues to piece together information about Fred Pearce's businesses. In his earlier years, he traveled close to sixty thousand miles a year visiting his different amusement industry interests.

Frederick William Pearce was born in Pittsburgh, Pennsylvania, on March 9, 1885, a son of Josiah and Emma (Clapp) Pearce, who had a family of eight children, only four of whom survived. He was educated in the Pittsburgh public school system, and he continued to live there until he entered into a business association with his father, who was an engineer on Cunard Line ships for many years.

That business was named Josiah Pearce & Sons, and it was organized in 1903. The firm consisted of Josiah, seventeen-year-old Fred and Fred's brother J. Eugene. The family had previously spent their vacation at the resort area located on Conneaut Lake, situated in northwestern Pennsylvania, and with Josiah's reputation in the field of boat construction, the family took great interest in the fleet of small boats that carried passengers around to the various resorts on the lake, the town of Conneaut Lake and the Hotel

Fred Pearce and his dad, Josiah. *Pearce Family Photographs, used with permission.*

Conneaut together with the nearby amusement park called Exposition Park (later known as Conneaut Lake Park). The family ran a grocery store in Pittsburgh until they accumulated enough money to buy a small steamboat for $600. For Josiah Pearce & Sons' first business venture, the company placed its steamboat, which carried fourteen passengers, into the waters of Conneaut Lake. Fred became the captain of the ship, and his father was the ship's engineer. The first season of operation netted the company's operation $300.

During the winter, the Pearces decided that there was more money to be made in a bigger boat, so their little craft was lengthened, at a cost of $1,100, to allow it to carry forty-two passengers. That next season, the operation turned in a net revenue of $1,100. Unfortunately for the Pearces, a larger company was formed by competing interests to buy up all the craft operation on the lake at the end of the 1904 season. Fred thought the company was formed to squeeze out all the small operators on the lake. The Pearces believed that it was not in their best interest to compete with this larger company, so they sold their boat for $1,425.

The off season between 1904 and 1905 proved to be a turning point for Josiah Pearce & Sons. The company had sold its Conneaut Lake excursion boat and was contemplating its options. What an interesting family conference they had on how they were going to "spend so much money." Back in Pittsburgh, the Pearces spent some time with the well-known roller coaster builder and park operator Theodore M. (T.M.) Harton, who had several concessions at Exposition Park. In reviewing the rides located at Exposition Park, Josiah Pearce & Sons came to the conclusion that the park did not yet have a new amusement ride known as an Old Mill. With that thought, the family's foray into the amusement park business via the combination of ride construction and operation began. Son Gene had previously been paymaster for the Gulf Company at Port Arthur, Texas, but with the glowing tales he

heard of the amusement business, it made him give up his position to help with the family business. He came north to Conneaut Lake and became part of the company while it was building the first Old Mill at Exposition Park.

An Old Mill was one of the rides popular at that time, 1905, yet missing from the Exposition Park ride lineup. Also known as a Tunnel of Love, the Old Mill is a sedate ride where flat-bottom boats travel down a cement trough on water that is powered by a large rotating paddle wheel. The tunnels are dark except for four scenes that riders can view during the ride, much like the one you see today at the Minnesota State Fairgrounds. But Fred Pearce found out that even mild rides like this one can cause operators headaches.

He once recalled the particular trouble the Pearces experienced with the company's first ride in a 1956 *Billboard* magazine article:

> *We had used new lumber along the sides of the passage-way through which the boats floated. The new boards reflected light, and since the tunnel had to be dark we coated them with lampblack. Well, it was the practice of young men to steal a kiss from their lady-friends in the dark tunnels, and some of them attempted to stop the boats so they could perform this delightful task. Best way to stop the boats was to put your hands against the sides. You can see what happened. The boys got lampblack on their hands, then transferred it to the girl's face—and when they came out there was tattle-tale black all over the young lady. The public soon caught on and would stand at the ride exit and gleefully note the condition of the young women who emerged. Needless to say, we had to correct that.*

After that summer, Josiah Pearce & Sons became concessionaires on a figure-eight coaster and merry-go-round at Fairyland Park near Paterson, New Jersey. Fred worked as a laborer at the park throughout the construction of the two devices so as to gain firsthand ride experience. Josiah remained as a manager of Pearce's Old Mill attraction at Exposition Park. Unlike modern coasters, this Fairyland Park figure-eight side-friction roller coaster had only two thousand feet of track and only cost $12,500 to build. After the rides were built, Fred stayed at the park and personally operated and managed the company's rides at Fairyland for five years. The figure-eight coaster grossed somewhere between $8,000 to $10,000 a year during its first two years of operation. Unfortunately, the 1907 depression hit, and the coaster's income dropped remarkably. Like many amusement parks that existed then, the depression took a toll on the amount patrons were willing to spend on outdoor amusements, and Fairyland went out of business a few

seasons later. After Fairyland closed, Fred made the decision that he would rather spend his time in the field of ride design and ride building and leave the operations to others.

It was at Fairyland Park that Fred made one of his few major adventures outside the amusement ride field. In 1905, an aviator named Hamilton was booked for the park. He showed up at the park with no money, and Pearce, who through his early experience realized the value of a good free attraction, provided the cash to fill the gas bag so the ascent could be made.

After the 1905 season, the Pearce family members again returned to Pittsburgh. Back in their hometown, they met a man in Pittsburgh who owned several theaters, then called nickelodeons, seating about four hundred people each and showing twelve minutes of motion pictures. The man's nickelodeon on Smithfield Street in Pittsburgh was doing quite the business, and it looked to provide large and immediate returns on an investment. People would line the street every day waiting to spend their nickels in the machine. The Pearces didn't want to go into the motion picture business in their hometown, fearing what their friends and family might say if it didn't do well, so they decided to enter the picture business in the South, where the mild winters appealed to them. The first movie enterprise for the Pearces started in Memphis. Fred continued to operate the Memphis location in the off season, while Gene went on to New Orleans and founded their second location in New Orleans, followed by ones in Birmingham, Alabama; Mobile, Alabama; Dallas, Texas; Monroe, Louisiana; Vicksburg, Mississippi; Lake Charles, Louisiana; Port Arthur, Texas; Houston; and Pittsburgh, Pennsylvania. Josiah Pearce & Sons eventually expanded to a total of seventeen theaters throughout the South and at one time operated seven motion picture houses in New Orleans alone, where it maintained its general offices until 1918. It also operated the largest independent film exchange in the United States.

Josiah Pearce & Sons became a pioneer in the motion picture industry, operating the third moving picture theater in the United States and the first one south of the Mason-Dixon line. Eugene Pearce, having previously lived in the South, moved back to New Orleans to handle a majority of the operations of the theaters in the South. While in New Orleans, Gene, who was older than Fred, and his wife made a home for his younger cousin, Fred Clapp, whose mother had passed away when Clapp was young. During the winter months, Fred Pearce would travel south to help out with the theaters and would go back north to operate the amusement rides during the outdoor amusement season. When the amusement park business slumped, the motion

picture business did well, and when the amusement business picked up, the motion picture business slumped.

The business of Josiah Pearce & Sons branched into the field of general park construction and operation, with a strong emphasis on rides. It had little to do with concessions, except as incidental to operation of the entire park. The business began to take off in 1910 when Fred built a roller coaster and placed a merry-go-round in Ocean View Park, Norfolk, Virginia, and a Scenic Railway at Blue Grass Park, Lexington, Kentucky. The Blue Grass Park coaster was possible with the financial assistance of T.M. Harton. Fred Pearce went on to perform much of the work at Ocean View Park, including the construction of the Old Mill, the Funhouse and the Whip, as well as supervise most of the building of other structures there for the park's owner, Otto Wells. Throughout the years, from the beginning, as if by instinct, Fred Pearce centered his rides and operations in amusement parks located near a lake or river.

It was on the Norfolk coaster that Fred Pearce first worked with a man named Joe McKee, who was Pearce's general superintendent on that project. McKee had experience building a number of coasters and worked several jobs with noted coaster engineer Charles Page, who reported their work to coaster designing legend John Miller. From Norfolk, McKee traveled with Fred Pearce to White City (known today as Lakeside Park) in Denver in 1911 to engineer and build a Derby Racer coaster.

At the same time, Pearce was also building a Derby Racer at Revere Beach, Massachusetts, located just north of Boston. The Derby Racers were both designed by John Miller, who would go on to design all the roller coasters the Pearces built except the first one at Fairyland Park. The Derby Racers were racing coasters where two separate coasters were built next to each other, and the riders in one coaster car would race the other coaster car to see who would finish first. Usually, the coasters, while built with the same support structures, may have some slight alterations to differentiate one side from the other side. The twin tracks of the Derby Racer were laid out in a figure-eight design. The Derby Racer at White City was operated by Pearce until 1924, when it was sold to park management, and the one at Revere Beach was operated until 1936. For the Derby Racer at Revere Beach, the Pearces joined with T.M. Harton to fund the ride at a cost of $140,000. The Derby Racer at Revere Beach, when it was built, was claimed to be the second-largest roller coaster ever built. It had 3,000 feet of track on each ride and was built four tiers high. The White City Derby Racing Coaster was built at a cost of $125,000 and was 3,800 feet long and wrapped around the park's ballroom and roller skating rink.

In 1915, Josiah Pearce & Sons built the Greyhound coaster for Riverside Park in Agawam, Massachusetts, as well as what was the most massive roller coaster of its time, the "Trip Thru the Clouds," in Michigan. This roller coaster was one that Josiah Pearce & Sons was most famous for and proud of building. The coaster was located at Milford Stern's Riverview Park at the Belle Isle Bridge in Detroit, Michigan, also known as Palace Gardens. The "Trip Thru the Clouds" was designed by Vernon Keenan with staggering statistics for 1915: It was ninety feet tall and more than a mile in length. It was claimed that this roller coaster ran six trains of three cars each, running one train every twenty seconds and using a crew size of twenty-four to operate it. It cost $110,000 to build, and it continued in operation until 1924, when the ride was dismantled. Years later, Fred Pearce said, "There has never been another coaster of its size anywhere in the world."

In 1916, Pearce built a coaster at Sugar Island Park on Sugar Island, Michigan. Sugar Island is a small island that sits near the southeast tip of Grosse Ile, a Detroit suburb. It began operation sometime in the early 1900s and ran through the 1940s as a small park with a large dance pavilion that catered to the Detroit African American population. Later in 1916, Pearce began work on the Dixie Flyer at Summit Beach Park in Akron, Ohio.

After Josiah's death in 1918, the motion picture interests and film exchange were taken over by Gene, along with the two roller coasters in Agawam, Massachusetts, while Fred took over the other coasters and outdoor amusement enterprises, establishing his general offices in Detroit, which had been his headquarters for a number of years even before Josiah's death.

A 1915 photo of Fred W. Pearce. *Pearce Family Photographs, used with permission.*

When Gene had his fill of motion pictures, he and Fred took over all the permanent rides on the Dallas State Fairgrounds and built, among other rides, a large coaster there. Gene gave all his time to Dallas until they closed out their interests at Fair Park. Then Gene moved to Springfield, Massachusetts, where he took over the coaster at Riverside Park, Agawam, Massachusetts, which had been running since 1915. They sold the coaster just before the park went under for an eight-year period of time. While operating the Riverside coaster during its final days,

Gene built and operated a funhouse in White City in Worcester that burned after about two years of operation. There was no insurance on the funhouse. Before this fire, Gene had taken over one of John J. Hurley's merry-go-round buildings at Revere Beach for an additional funhouse. This acquisition happened just before the Great Depression in 1929. Gene had agreed to one of those high-rental contracts that prevailed at the time. By renting each front corner for other concessions, he could have gotten by but for the depression, which changed the whole complexion of Revere Beach. After that, he went back to Walled Lake to manage the park.

From 1918 to 1920, Fred W. Pearce & Company built a number of roller coasters, including the Jack Rabbit at Capital Park, outside Lincoln, Nebraska; Cannonball Coaster at the legendary Riverview Park in Chicago; Cannonball Coaster at Riverview Park in Baltimore; Giant Coaster at

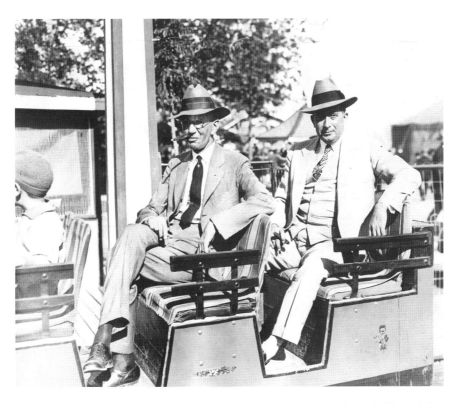

Eugene and Fred Pearce in the summer of 1927. *Pearce Family Photographs, used with permission.*

Riverside Park in Agawam, Massachusetts; and the Dips in Liberty Park on Lake Goguac, located south of Battle Creek, Michigan.

In addition to being the head of several corporation subsidiaries to Josiah Pearce & Sons, Fred became a director of the Ingersoll Engineering & Construction Corporation. He was also instrumental in the early formative years of the National Association of Amusement Parks in the early 1920s. Other places in the United States where Fred Pearce had ride interests included parks in Los Angeles, Cincinnati and Cleveland.

At Pleasure Beach, Bridgeport, Connecticut, Pearce shared the construction of the park with Harry C. Baker, of the firm of Miller & Baker. One of Baker's most prominent construction jobs was building the still-standing Cyclone at Coney Island, Brooklyn, New York. Baker was in charge of building most of the structures on the island, while Pearce built the roller coaster and handled marine construction, which included the erection of two large docks, including one in the city of Bridgeport; dredging; and bulkheading. Pearce also spearheaded the rebuilding of two boats with a capacity of two thousand passengers and fifty autos each. The coaster was known as either Sky Rocket or Deep Dip Coaster, and it was built by Pearce in 1921. By 1922, Pearce had been named the president of the park and oversaw its operation.

From 1921 to 1923, Pearce was again involved in several different park projects. The Thunderbolt at Westlake Park in Bridgeton, Missouri, was built in 1921. In 1922, Pearce went back to Lexington, Kentucky, to modify and enlarge the Scenic Railway at Blue Grass Park. The new coaster was known as the Giant Coaster. Pearce and his team worked in Oklahoma during the winter of 1923 to erect the Jack Rabbit (or Dips) wooden coaster at Sunset Park in Tulsa. Later in 1923, Pearce and his team were busy erecting the wooden coaster also known as Big Dipper at Chippewa Lake near Medina, Ohio. This coaster is similar to the Big Dipper, which ran at nearby Geauga Lake Park in Aurora, Ohio. Pearce was also busy constructing the Sky King at the Wisconsin State Fair Fairgrounds in West Allis.

Earlier in the fall of 1924, the Pearce Company was busy erecting a coaster at Luna Park in Hull, Quebec, Canada, with many of the same staff overseeing that project who would come down to Excelsior. The coaster was designed by Vernon Keenan, with L.C. Addison supervising the construction. The coaster was known as the Sky Chaser. It opened on May 22, 1925, but closed three seasons later, which is likely when the park closed, as well. While constructing Excelsior Park, Fred Pearce gained the management contract for Wildwood Park in Willernie, Minnesota, and constructed a new wooden coaster there for the 1925 season called The Pippin.

After opening Excelsior Amusement Park, the Fred W. Pearce & Company did not rest on its laurels. It built a roller coaster at the state fairgrounds in Dallas, Texas, sometime shortly after Excelsior opened. Following close behind was the construction of the Chain-of-Rocks Park. Pearce and his team were busy building most of this park, located outside St. Louis. In fact, Pearce built everything at the park except the swimming pool, a restaurant and a few minor rides. The construction of the coaster for Chain-of-Rocks reconnected Pearce with coaster construction expert Joe McKee.

The biggest single park job that Pearce constructed was Jefferson Beach Park in Lake St. Claire outside Detroit. Pearce constructed the park in 1927 at a cost of $1.25 million and operated it for a number of years. The most difficult job in that park, as Pearce later recalled, was the construction of the ballroom on the second floor over the bathhouse. Like most of Pearce's coasters, the initial design of the Jefferson Beach Park coaster was completed by John Miller; this ride was called Thunderbolt.

New ride and park construction took a brief hiatus in the fall of 1927 as Fred Pearce took on the responsibility of being named the president of the National Association of Amusement Parks, Pools and Beaches (NAAPPB). During the year of his presidency of the association, Fred Pearce visited more than fifty amusement parks throughout the United States during the short summer season, and he found this pace very demanding. Pearce did less building of rides at other parks after 1930 and confined himself mainly to the Detroit area and the Twin Cities. However, journals at the Excelsior Lake Minnetonka Historical Society written by Rudy Shogran mention Pearce being taken to the train depot for his ride over to Capital Beach in Lincoln, Nebraska.

As his NAAPPB presidency came to a close, Pearce's vision turned closer to home, and he began looking to build a park of his own. Pearce made a deal to lease land on Walled Lake near Novi, Michigan, and he went to work constructing his park, which originally opened as Pearce Park. The Pearce Park coaster was the same coaster that Pearce built for Sunset Park in Tulsa; it was moved to Pearce Park and reconstructed. They named the coaster Flying Dragon, and the park was later known as Walled Lake Park. The park also had rides like the Pretzel dark ride and a Tilt-A-Whirl.

During the 1930s, Fred Pearce became an officer and trustee of the American Museum of Public Recreation, located in Brooklyn, New York. This museum, according to a brief prospectus of the organization, was the first institution devoted to public reaction to play as expressed through facilities that man has created and developed, as well as for the preservation of the historical development of public outdoor recreational facilities of the past and present, for the enlightenment and entertainment of this and future generations.

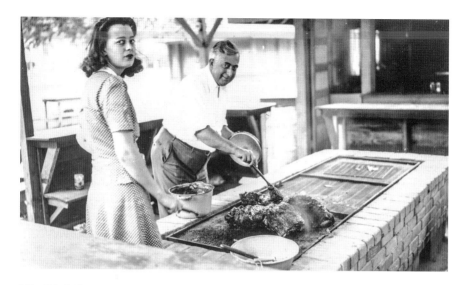

Miss Ethel "Bunnie" Pearce and her dad, Fred W. Pearce, grilling at Pearce's Walled Lake Amusement Park. *Pearce Family Photographs, used with permission.*

The offices of Fred W. Pearce & Company, one of the largest park and coaster operators in the country, were moved in March 1944 to the Nottingham Building at 15324 East Jefferson Avenue in Detroit, Michigan. This move was the firm's first in twenty-three years, during which time the offices had been in the Knickerbocker Theater Building across the street from the former site of Riverview (formerly Electric) Park. The need for larger quarters led to the move. At the time of the move, the Pearce organization included a string of park companies—Walled Lake Park Company, operating Walled Lake Park; Pearce Amusement Company, operating the roller coaster at Chippewa Lake, Ohio; Pearce Coaster Company, operating the roller coaster, Whip, skee ball alleys, shooting gallery and Haunted Castle at Chain-O-Rocks Park St. Louis; Excelsior Park Company, operating Excelsior Park; Lincoln Coaster Company, operating the roller coaster at Westlake, St. Louis, Missouri; and Bridgeport Coaster Company, operating the roller coaster at Pleasure Beach Park, Bridgeport, Connecticut. These various corporate entities were necessary for Pearce to operate his rides and concessions within the different states, plus they helped to insulate the main Pearce corporation from liability for any catastrophic loss at any one of the locations. Even though the offices were in Detroit, Pearce always made time for his operation in Excelsior. In 1945, Eugene, who had managed the Walled Lake location since the mid-1930s, died.

Fred Pearce in 1930 (*left*) and 1950 (*right*). *Pearce Family Photographs, used with permission.*

Everything in the many parks and attractions that Fred Pearce built was personally supervised by him. Pearce had this uncanny ability to envision new ideas and carry them out in an actual park operation. He would be on the job personally supervising work when it came to construction at his parks or attractions. At Excelsior Park, not only did he spend a month there supervising the rebuilding of Excelsior Park's pavilion stage—including a dressing and radio control room for the radio show broadcasted from the park in the previous fall—but also, a number of years later, he spent another month in preparation of a new picnic grove on the east end of the park. He returned from Excelsior's construction of its new stage to Walled Lake, where he supervised the construction of the park's new dock facilities.

Personal attention to details had been important in Pearce's park and ride operations. He was constantly learning about paint qualities, mechanical devices and uses of alloy steels. He also pioneered the use of pressure-treated creosote lumber for roller coasters, which gave the coaster structures adequate protection against rot and decay, decreasing the number and cost of subsequent wood replacements.

What else did Pearce do for his rides and parks? Pearce found his niche in concentrating on planning, policy decisions, financing, improvements,

Ethel Pearce with her father, Fred. Ethel was the firstborn of Fred Pearce's six children. *Pearce Family Photographs, used with permission.*

promotion and central office operations. He empowered his local managers, like Joe Colihan and Fred Clapp at Excelsior, to oversee the operating details. Fred favored a ride or park that was geared toward families, one that could sustain or enhance the operation of group picnics. He also preferred a park with a small number of rides and games relative to space devoted to recreation areas. Typically, he did not operate amusement concessions except games of skill, and in the parks that his company wholly owned, the attractions and concessions were operated by the park management and not normally by any outside concessionaire.

Outside of his life as a businessman, Fred W. Pearce managed to have a personal life as well. Fred was married in November 1915 in New Orleans to Ethel Hayward, a native of New Orleans who was the daughter of a prominent cotton broker. They became parents to two children. The oldest child was Ethel Pearce (MacMahon), who was born on March 6, 1917, and was also known by her nickname, "Bunnie." The other child was Frederick William Pearce Jr., who was born on February 6, 1920. Mrs. Ethel Pearce (Fred's first wife) died in 1932. In 1936, Fred married Fern Hickey of Port Huron, Michigan. The marriage to Fern brought forth two daughters, Elizabeth and Julie. After the death of Fern in 1951, Fred married a third time to Marian Higgins Pearce in July 1952. Fred and Marian were parents to two lovely girls, Katheryn and Martha. Fred resided in Grosse Pointe, a suburb of Detroit, for nearly the last twenty years of his life. Once Fred had stopped his crazy building sprees in the off season, you could usually find him relaxing on vacation during January and February in south Florida.

With the death of Fred W. Pearce in 1959, Fred Pearce Jr. was designated by the Pearce family to oversee the management of the operations of Walled Lake and Excelsior. Fred Jr. grew up in the business, working summers at the parks while going to school for three and a half years to the University of Michigan but had to leave school due to the family

Left: Fred Pearce stands in the center of this 1934 photo with his two oldest children: Fred Pearce Jr. (*on his right*) and Ethel (*on his left*). *Pearce Family Photographs, used with permission.*

Below: Wedding photograph of Fred W. Pearce and his third wife, Marian Higgins. *Pearce Family Photographs, used with permission.*

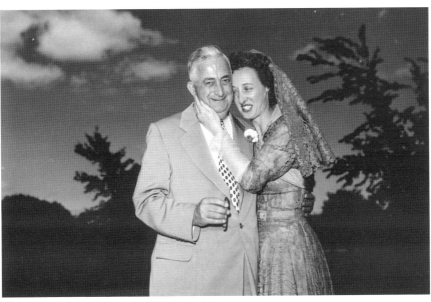

Fred Pearce Sr. with his daughters Julie and Elizabeth. *Pearce Family Photographs, used with permission.*

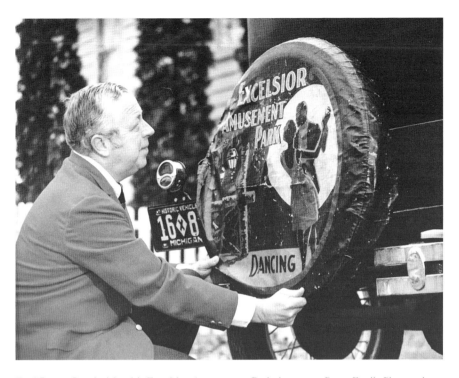

Fred Pearce Jr. admiring his Excelsior Amusement Park tire cover. *Pearce Family Photographs, used with permission.*

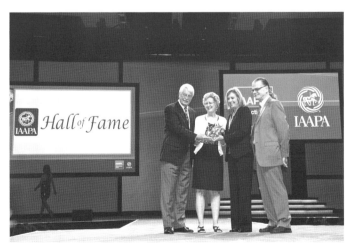

Receipt of the award inducting Fred W. Pearce Sr. into the IAAPA Hall of Fame in November 2011. *From left to right*: grandson Chuck MacMahon, daughter Kate Pearce, daughter Martha Falcon and presenter Tim O'Brien. *Pearce Family Photographs, used with permission.*

business. Fred Jr. received national publicity in the summer of 1943 when, while stationed with the Coast Guard in Staten Island, he rescued a woman who fell or jumped off the Staten Island Ferry due partially to his time spent as a lifeguard while working for his dad's amusement parks. He joined his father Fred's business on a full-time basis in 1943, dividing his time between the parks and the theaters. In 1964, Fred Jr. followed in his father's footsteps and became the president of the International Association of Amusement Parks, the successor to the NAAPPB.

To recognize his nearly lifelong dedication to the outdoor amusement industry, together with his innovations to roller coasters, like using pressure-treated creosote lumber in his construction, the International Association of Amusement Parks and Attractions (IAAPA), an organization for which Fred Pearce was an early organizing pioneer, inducted Frederick William Pearce Sr. into its Hall of Fame in November 2011.

MANAGEMENT THROUGH AND AFTER THE GREAT DEPRESSION

The year 1930 started a new chapter in the history of Excelsior Park. In October 1929, the stock market crashed, throwing the United States into its Great Depression. For the most part, the outdoor amusement industry had completed its season, so amusement businesses had the opportunity to anticipate how the new business environment would affect operations for the 1930 season. At Excelsior, Fred Pearce brought in two new managers to help operate the park. Pearce looked inside his current park operations and decided to send Joe Colihan to Excelsior. Colihan started his position at Excelsior Park as the rides supervisor and assistant manager. He had been working for Fred Pearce the last five years managing Pearce's roller coaster at Pleasure Beach Park in Bridgeport, Connecticut. Pearce also brought in a new publicity manager for the 1930 season, R.S. Shogran. Shogran took over the duties of booking orchestras at the ballroom, creating ads for the park, hiring the special attractions and setting up picnic outings at the park. These new managers, together with Bill Clapp, would help Excelsior Park weather the economic storm of the Great Depression and guide the park into the age of television.

Joe Colihan, born and raised in Danbury, Connecticut, grew up in the amusement industry, as his father, John, operated rides at fairs, carnivals and in amusement parks. Joe grew up working on rides for his dad at fairs during the summers and slowly gained international industry experience prior to his job at Pleasure Beach Park. He had worked as a ride man with the Johnny J. Jones Exposition; worked with the legendary ride firm of Traver

Engineering Company for five years; spent time with Joe and Al McKee in Palisades Park, New Jersey; and had experience with carnival owners Bennie Krause in Cuba and Puerto Rico and with Joe Goldberg in South America. It was during his first season working in Bridgeport that Colihan met Marion Kerrigan, a Bridgeport, Connecticut girl. They were married on April 26, 1926, and eventually had a son named Raymond.

R.S. (Rudy) Shogran was a resident of California who made the Andrews Hotel in Minneapolis his home. While not much is known about his background before coming to Excelsior, he left quite a lot of evidence of himself and his work behind in Excelsior for everyone to review. Shogran was quite detailed in his work, as a majority of the marketing managers in the amusement industry tend to be, keeping a day-to-day journal of each day's activities, weather and ballroom attendance. Shogran also kept a continuing scrapbook in which he taped ad copies, published advertisements, bills, event handouts and event tickets together with magazine and newspaper articles. These things were so much of Rudy's work habits that in a 1937 journal, he chastised the previous marketing manager for not keeping tabs on the advertisements while he was away and for not keeping a list of sales contacts. Based on Shogran's detailed work, a good deal of information is known about the daily happenings at the park during his time here. These historical gems are now accessible to the public at the archives of the Excelsior-Lake Minnetonka Historical Society.

The 1930 season began a period of special free attractions at the park. With the prospect of large capital improvements improbable due to the stock market crash of 1929 and the ensuing depression, the park sought other ways to enhance the visitor experience at the park. Special free attractions would give people a new reason to visit the park during the same season even though a new ride was not feasible. These special free attractions were made possible during the 1930s because they involved entertainers looking for employment during hard times and betting that their talent was of such interest that it might increase the percent of the normal receipts that a park might make on the day they perform. For the park, this relationship was good because you could change attractions while minimizing your capital outlay necessary to book the performers. In essence, the split of the receipts was viewed as a win-win for parks and performers. Even with the supply of money being tightened, Excelsior was fortunate enough to provide other new features at the park for the 1930 season, including new caricature drawings appealing to young and old in the Funhouse, a new boardwalk that was built along the lakefront and a

new speedboat, a Chris-Craft, which proved to be an excellent attraction for park visitors.

As the person newly in charge of picnics, Rudy Shogran expressed his disappointment that employer committees were favoring outside places such as city parks, spring parks or lakes where they could be private and have private dances, lunch and large grounds for games. Shogran had even taken care to quote committees the distance to the park and car fare. He also said that parents didn't want to go to the park, where kids could see the rides, and use money, which had been scarce while many parents were out of work.

Shogran soon discovered that the park's free sensational programs were strong draws for the farmers in the area. After the fireworks of July 4, visitors that July saw performers attempting double parachute jumps over Lake Minnetonka. For this attraction, a parachutist would eliminate one chute and then open the second chute while freefalling. To kick off August, Shogran hired Captain Jack Payne, who proved to be a big draw for the park each time he was booked. Captain Jack was originally from Minneapolis and learned how to dive off the Hennepin Street Bridge. He had been barnstorming for about fifteen years with a troupe that dove at the Minnesota State Fair. Payne's high dive was billed as a fall off a platform one hundred feet into the air blindfolded and leaping backward down into a five-foot-deep tank of water that was blazing with fire. Captain Jack Payne's High Dive took place in front of the Funhouse. Like most attractions, Captain Payne's involved

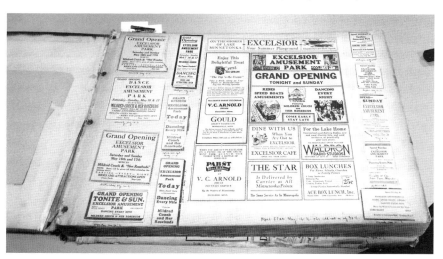

A view of the material collected in the Excelsior Park Marketing Scrapbooks, now in the possession of the Excelsior–Lake Minnetonka Historical Society. *Author's photo with permission from the Excelsior–Lake Minnetonka Historical Society.*

Left: Excelsior Park Marketing Scrapbook. *Author's photo with permission from the Excelsior–Lake Minnetonka Historical Society.*

Below: Newspaper front page handed to visitors at the grand opening of the park in 1930. *Author's photo with permission from the Excelsior–Lake Minnetonka Historical Society.*

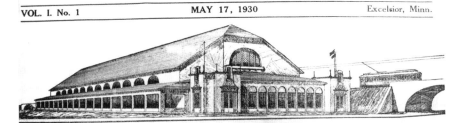

some optical illusions. While the side of the tank measured five feet, the Excelsior maintenance crew took great pains to disguise the deeper hole they dug under the five-foot tank of water into which Captain Jack plunged that added to the optical illusion of his act.

On Sunday, August 24, 1930, Excelsior Park experienced its first performance accident. The park had hired Captain George Babcock to perform a triple parachute jump at the park during the middle to end of August. On this particular day, Captain Babcock's jump went horribly

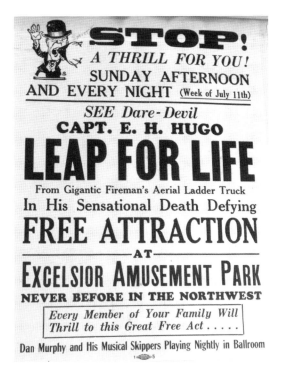

Poster for Captain Hugo's Leap for Life free attraction. *Author's photo with permission from the Excelsior–Lake Minnetonka Historical Society.*

wrong, and he hit the water from about 2,500 feet in the air. He was found dead in the waters of Lake Minnetonka, with every bone in his body broken or crushed.

Every year, Excelsior Park would pay a large group of men to help in reconditioning its rides, painting parts of the park and conducting other start-up maintenance work to get the park ready for its yearly opening. The year 1931 would be no exception, as the Pearce Company hired fifty workmen for several weeks to recondition rides, paint and redecorate the ballroom and complete other finishing touches, all at a cost of $5,000 for the park's seventh annual opening. The official opening was inaugurated with a ball held at the ballroom at which roses were given to all women and girls who attended. New speedboats were purchased to replace those destroyed by a fire at winter storage quarters in the off season, and the new boats were placed in operation at the park's official opening for the 1931 season. By this time, the park's ride lineup included the Giant Roller Coaster, the carrousel, the Funhouse, Skooters, the Whip, the Tilt-A-Whirl, airplane swings, the Caterpillar and the Honeymoon Trail.

Each year, Excelsior Park looked forward to its annual Fourth of July fireworks celebration, and 1931 was no exception. But rain poured down

from the sky for most of the day and night, leaving the park with no other choice than to postpone its fireworks show to Sunday evening, July 12. The postponement of the fireworks turned out to be fortunate for the park, as it experienced a large crowd on July 12, with customers staying late until 10:30 p.m. that evening to watch the fireworks display. Five days later, the park had again booked Captain Jack Payne for an eight-day stay, including two performances on Sundays, as a part of its package of 1931 free entertainment attractions.

Right after Captain Jack Payne's appearance, the park booked the first appearance in the northwest of Oscar Babcock, an acrobat with a bicycle. Even though the daredevil was just one year away from being eligible for federal old age pension, Oscar said that the only reason he continued to seek the thrills was because he had sawdust in his blood. He was booked to perform his thrilling and sensational "Loop the Loop" free act for a week. In this act, Babcock would ride his bicycle down a sixty-five-foot incline through a trapdoor and around a giant loop, followed by jumping a thirty-five-foot gap in the ride platform. To greater enhance the thrill of the performance, the park's advertising of the feat noted that Babcock would be riding down the incline at a rate of seventy miles an hour leading into the wooden loop. Oscar Babcock's act was so warmly received by the park's patrons that Excelsior Park brought him back in a return engagement the same season before the park's Labor Day events.

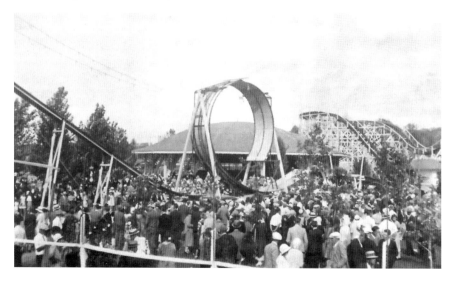

Looping apparatus of cycling stuntman Oscar Babcock. *Author's photo with permission from the Excelsior–Lake Minnetonka Historical Society.*

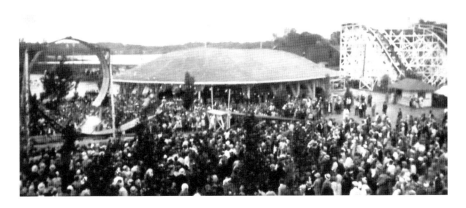

The bicycle jump structure for Oscar Babcock, a popular free attraction at the park in the 1930s. *Author's photo with permission from the Excelsior–Lake Minnetonka Historical Society.*

The park introduced another type of free attraction for the 1931 season when it booked the "Wizard of the Wire," Prince Nelson, for August. Nelson was billed as being no more than five feet tall and weighing less than 110 pounds. He was known for his dizzying high-wire acts in which he danced and pranced his way over a high wire eighty feet in the air without a net.

To ensure that the people of the Twin Cities would remember the park during the off season, Excelsior Park liked to hold some memorable event near the end of the operating season. The park's last free act for 1931 was to invite the public to attend the wedding of Michael Wrona and Beatrice Prevost, held at the park on September 12. The park's picnic pavilion was the site of the wedding, and it was said that Excelsior Park spared no expense in staging the ceremony. Rudy Clemmenson's Orchestra, which was performing at the park's spacious ballroom at the time, provided the music. The reception and wedding dance took place over in the park's ballroom. The bride got to cut a huge wedding cake to serve to all park patrons in attendance. Wedding souvenirs were distributed by the groom at the end of the grand march.

The Tavern was the park's new addition for the 1932 season. With the decline of Prohibition in sight, the park needed a place where it could regulate the sale of bottles of beer and could serve as a sit-down restaurant in which park attendees could visit and enjoy the park's food. While the new restaurant was being built, Rudy Shogran was busy booking free acts for the season. Shogran booked Dick Hunter's Mile High "Leap for Life"

double parachute jump in early June to kick off the season's parade of free acts. Hunter would fall out of the plane and open the first parachute. That first parachute would come off, and Hunter would freefall some more before engaging his second parachute. You can just imagine the anticipation felt by the crowd that gathered when Hunter would freefall after his first parachute opened.

Shogran also had Al Blackstone, famous for his "Flying Circus," stop by the park in 1932 to give an exhibition, including walking on the wings of an airplane traveling over Lake Minnetonka, flying right in front of the park. His feats included some wing work, hanging by one arm, hanging by one leg and hanging by his teeth from the bottom of a ladder suspended from his airplane. His feats of daring kept all those watching below holding their breath. Later that same evening after Al Blackstone performed, Dick Hunter completed his double parachute jump together with illuminated parachute men doing sky bombs and flares. This stunt was particularly perilous because the act was performed in the dark.

Transportation to the park was forever changed when the last streetcar ran to Excelsior in August 1932. As a result of this change, during the winter of 1932, Excelsior Park had to do a whole reinstall of the type of power that was furnished to it. This change of supplied power was necessary due to the abandonment of the trolley lines. Previously, the park's power was bought from the trolley company, and it was direct current. With the installation of the new motors during the off season, the current became alternating current, now to be supplied by the Northern States Power Company.

Even though Prohibition was waning in 1933, it did not mean that people were fully comfortable chugging down alcohol in public yet. In his 1933 journal for the month of May, Shogran wrote that park visitors were "spending a half-hour with one bottle of beer and that was affecting the rides and other concessions." Based on the lower sales of beer as well as dance tickets for the ballroom, Shogran had started putting his "home" telephone on the dance tickets. He noted that although his phone was constantly ringing, tickets weren't being used at the ballroom. Rudy mentioned that the rain situation in the month of May made him "goofy from worry night to night."

The rain of May turned into the heat of June during that summer of 1933. The park's free attractions took off on Sunday, June 18, when the park featured a parachute performance by an artist called "Mystery Girl of the Air." Due to the particularly warm June day, a nice crowd had gathered around the lake for the Mystery Girl's performance. During her act, her

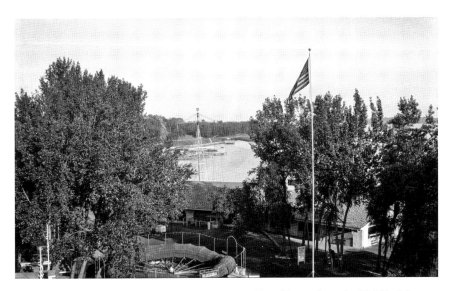

EXCELSIOR
AMUSEMENT PARK
Phone: Excelsior 25

Minneapolis Office:
1775 Hennepin Ave.
Phone: Kenwood 0632

Excelsior Amusement Park
"By the Waters of Minnetonka"

R. S. SHOGRAN

Above: Picture from the lift hill of the roller coaster showing the caterpillar ride in the foreground and the aerial swings over the top of the Skooters building, *Pearce Family Photographs, used with permission.*

Left: Business card of Excelsior's longtime publicity man, Rudy Shogran. *Author's photo with permission from the Excelsior–Lake Minnetonka Historical Society.*

parachute failed to open. So, the Mystery Girl, Delia Parker, pulled her emergency chute, but she was too late—the warm wind swept her emergency chute from over the water, where she planned to land, over to the concrete ramp at the Blue Line Dock, where she landed with a *thud*. An article in the *Minneapolis Journal* the following morning explained the incident this way: "In an eagerness of a girl parachute jumper at Excelsior to give the crowd a little greater thrill than usual landed her in General Hospital today with a fractured leg and badly lacerated face. Delia Parker, 26 years old, who is employed in a home of a Fort Snelling officer and does parachute jumping as a sideline fell several hundred feet before she pulled the ripcord to open her parachute. The wind swept the chute from over the water, where she planned to land and she fell on a concrete ramp."

According to Shogran, the weather that day was hot and blistery. Mystery Girl broke her leg in two places and sprained the other one. The park asked the ballroom band to go out into the park and begin playing to

help drag the crowd back to the park again. Shogran stated that the park in 1933 was pulling not even a third of the crowds it did in 1932 despite the fact that the band at the ballroom was played on WCCO radio every Tuesday and Friday evenings.

The park's Fourth of July weekend in 1933 was very nice. It featured the famous Smith's Diving Ponies. The act consisted of live ponies climbing a tower fifty-five feet high and then diving into a "shallow" tank of water. With most diving acts, one could never be sure that the size of the pool was actually the size of the visual landing area. Smith's Diving Ponies drew good crowds for the park on the weekends but did not draw as well as hoped for during the weekdays on which the act was booked.

Excelsior Park teamed up with local radio station WCCO to host a WCCO night at the ballroom in hopes of boosting the ballroom's attendance in August. The one problem that the park had to contend with is that in order for WCCO to agree to sponsor the night, the park was required to give the station 50 percent of the ballroom take for the evening. The park was glad for a good night of selling beer, as it was able to keep all of the profits from the beverages.

Rudy Shogran clearly documented Prohibition's waning stranglehold on society in his journal in 1933. In his search to determine why people were not coming to the ballroom in the same numbers as previous seasons, he spent time visiting what he termed the honky-tonks from Excelsior to Hopkins. He found that they had crowds gathered who were drunken, loud, talking and slopping of beer. This type of crowd was disgusting to Shogran, but he seemed to think that is what the people wanted in 1933.

On September 1, 1933, an armed man broke up the dance in the pavilion when he brandished a gun as he walked into the pavilion. Eyewitnesses said that he was loading his pistol as he made his way down the aisle. People began to flee, and in the excitement, the armed man went to his car and fled the scene without hurting anyone. The sheriff deputies picked him up the following day. The armed man said that he did not know where he got the gun. The deputies found an empty bottle of alcohol in the car.

Although they were known as the San Antonio Siamese Twins, Daisy and Violet Hilton, leaders of an orchestra that played at Excelsior Park on September 1, 1934, were born not in America but in Brighton, England. The name under which they are so widely known is derived from the American city to which they were brought by their adoptive parents. The twins lived in San Antonio the first fifteen years of their lives. In being the only living Siamese twins (twins who are born joined together) at the time,

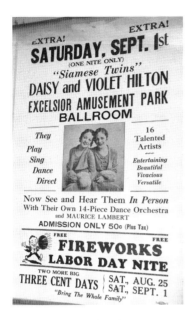

EXTRA! EXTRA!

SATURDAY, SEPT. 1st
(ONE NITE ONLY)

"Siamese Twins"
DAISY and VIOLET HILTON
EXCELSIOR AMUSEMENT PARK
BALLROOM

They	16
Play	Talented
Sing	Artists
Dance	Entertaining
Direct	Beautiful
	Vivacious
	Versatile

Now See and Hear Them *In Person*
With Their Own 14-Piece Dance Orchestra
and MAURICE LAMBERT

ADMISSION ONLY 50¢ (Plus Tax)

FREE **FIREWORKS** FREE
LABOR DAY NITE

TWO MORE BIG
THREE CENT DAYS | SAT., AUG. 25
| SAT., SEPT. 1
"Bring The Whole Family"

Handbill proclaiming the appearance of the Siamese twins at the park. *Author's photo with permission from the Excelsior–Lake Minnetonka Historical Society.*

people were interested in their appearance, but a large number of their admirers found them as more than a mere curiosity or freak attraction. The twins offered genuine talent and entertainment in music, song and dance to their audience. The Hilton sisters brought with them their own orchestra of fourteen artists, directed by the twins themselves.

One of 1935's free attractions was the "Human Cannonball." Wilno, who had practiced the act so many times he could not count them all, was shot out of a cannon twice daily in mid-July. The one big tense moment during each performance is that short time before he is blasted out of the cannon. After being shot from the cannon, he lands in a big net set up to catch him. As he bounces up from the net, he takes off his white mask, a part of his asbestos uniform that makes him look like a ghost, and bows and the act is over. Wilno, whose real name was William Wiedrich, was from Germany. He performed his first act in Germany in 1925 and had been in the United States performing it since 1930.

Planning for Excelsior Park's 1937 season began with management's participation in a Detroit strategy session with managers from the other amusement parks owned or operated by F.W. Pearce & Company. The conference focused on the latest marketing strategy in the amusement industry: the use of school picnics to drive family preferences. The conference went so well that Rudy Shogran remarked in his journal, "Detroit experience has given me confidence to tell what really can be done at the school picnics. I look for good results."

After spending some time away at other Pearce-owned park properties, Shogran returned to Excelsior for the 1937 season and encountered a change in the dance scene. He remarked in June of that year that "Saturday nights are sure different with the young folks and drinking and the new truck dance." He also thought that the cutting-in business, which had developed in his absence, though not a harmful thing was annoying to many people who were dancing at the ballroom.

Script Tickets Required on Rides and Amusements at Excelsior Park

Coaster	4 - 5c Tickets	Fun House	4 - 5c Tickets
Pretzel	2 - 5c Tickets	Tilt-a-Whirl	2 - 5c Tickets
Whip	2 - 5c Tickets	House of Mystery	2 - 5c Tickets
Merry-Go-Round	2 - 5c Tickets	Ferris Wheel	3 - 5c Tickets
Caterpillar	2 - 5c Tickets	Silver Streak	3 - 5c Tickets
Airplane Swings	2 - 5c Tickets	Miniature Railroad	2 - 5c Tickets
Flying Scooters	3 - 5c Tickets	Kiddie Auto (Children Under 12)	1 - 5c Ticket
Skooters	2 - 5c Tickets	Kiddie Whip (Children Under 12)	1 - 5c Ticket

SCRIPT TICKETS NOT GOOD ON BOATS, REFRESHMENTS OR DANCING

Ticket requirements for the park rides. *Author's photo with permission from the Excelsior–Lake Minnetonka Historical Society.*

Another revenue staple of modern amusement park operations is school picnics. School picnics provide amusement parks the opportunity to serve food to a group of people at a set price that together with a base ride package (or pay-one-price at today's parks) will more than offset the expenses to host the picnic. Then the park makes additional revenue based on the additional purchases of food and merchandise by the outing attendees. One instance of this dynamic at Excelsior Park occurred during the large Ascension school picnic the park held on Monday, June 7. Eight buses holding about four hundred kids, two priests and twelve sisters came to the park. The schoolchildren were fed lunches at a cost of thirty-five cents, while the adults were fed lunch at a charge of fifty cents. Excelsior Park sold lots of extra tickets to the picnic attendees. The school's priests, Fathers Dunphy and Meagher, were well pleased with the event, as the children had lots of fun without much work on the part of the school.

Later in the evening, that same day, one can read that Rudy Shogran was still getting his feet back under him upon his return to his promotional job at Excelsior, as he noted that the band that was playing at the park that night had drawn a bunch of kids who trucked and raced around ("truck" was a shuffling jitterbug step, with origins in 1935). Shogrin goes on to note in his 1937 journal that those who truck are "[o]f a different class of people." He also noted in that journal that Excelsior Park experienced "much cheating on tickets goes on nightly, but park is watchful."

One of the free entertainment options this year, by popular request, was movie stuntman Harry Froboess and his death-defying act on a thin swaying pole one hundred feet in the air, leaving the spectators gasping. His performance proved the thrill of the season. Another free act for 1937 was Toots, known as the Wonder Dog. Toots leaped from a one-hundred-foot ladder in the air into a net below at the command of his master, while her sister, Nippy, leaped from a platform half the distance. Both dogs climbed the ladder at the same time and made separate jumps at the command of their master. Both dogs were wire hair terriers. Toots was two and a half years old, while Nippy was one and a half years old.

One of the park's promotions in 1937 involved the local food corporation, General Mills. Known as Wheaties Day, patrons would get one free ride by showing three Wheaties package fronts. Attendees would take their package fronts to the Wheaties ticket booth to get their free tickets.

Some of the musical entertainment in 1937 included not only Gould's sixty-piece Banjo Orchestra, a band that won awards at major music competitions throughout the country, but also a battle of the bands sponsored by local radio station WCTN. The battle of the bands, which occurred at the end of the season, pitted Joe Billo and his swing-type dance band against Whoopee John and his old-time polka dance band. The dance patrons were the judges who decided which band was the winner.

For Excelsior's annual Apple Day in 1937, the park decided to build the largest apple pie in the world, so large that it was baked in four sections. The main street of Excelsior was closed to traffic all day, and during the

This is Your Invitation to Come to Excelsior Park

THE PICNIC WONDERLAND

When you plan your class outing, or "skip day" trip, to various educational centers in or near the Twin Cities, may we suggest that you include in your program a visit to Excelsior Park. Excelsior Park is located on the shores of famous Lake Minnetonka, on highway No. 7 at Excelsior, Minnesota, just 11 miles from the city limits of Minneapolis. Special reduced rates are given to school groups.

Here you will find a delightful picnic park with acres of various amusements, including Speed Boats and a beautiful ballroom for dancing.

For many years we have entertained school and church outings from all over the state, as well as many industrial and fraternal organizations.

The best of food is served in our lunch stands and restaurant at popular prices, and we are prepared to serve special picnic lunches to groups—if arranged for in advance.

Please write us for further information.

EXCELSIOR PARK, Excelsior, Minn.

If you use regular bus or train service to the Twin Cities please note the bus schedule enclosed herewith from Minneapolis to Excelsior and return.

Many Suburban Schools Use Their Own Buses

SCHOOL BUSES UNLOADING AT EXCELSIOR PARK

An invitation to hold your school picnic at Excelsior Park. *Author's photo with permission from the Excelsior–Lake Minnetonka Historical Society.*

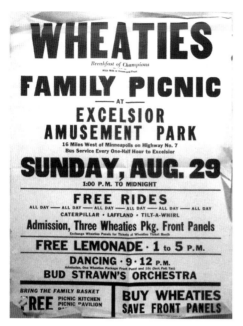

Left: Poster announcing the upcoming family picnic at the park sponsored by General Mills. *Author's photo with permission from the Excelsior–Lake Minnetonka Historical Society.*

Below: Ticket to the Shopping News family picnic. *Author's photo with permission from the Excelsior–Lake Minnetonka Historical Society.*

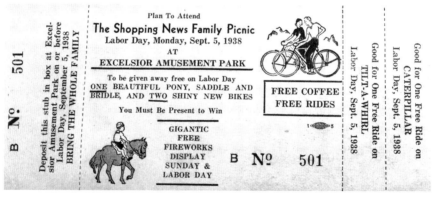

day, free acts, games, concessions and circus acts performed on Main Street. Special lighting effects were arranged for the evening festivities, culminating in a large Apple Day dance in the ballroom. Of course, what would be a town celebration without the crowning of the Apple Day Queen and her attendants, which happened at the amusement park pavilion.

The annual free Shopping News Picnic was a staple of the park during these years. For 1937, a huge fireworks display was added. Part of the prizes for the picnic included a pony, a puppy and boys' and girls' bicycles. Free coffee and cream were provided to all families that brought their own lunch to the park.

In May 1938, Excelsior acquired additional property to better accommodate the large crowds that came to the park. For the beginning of the season, the park acquired six speedboats for fast rides on Lake Minnetonka. The New Blue Line Café had been installed at the park for those patrons who wanted to enjoy an excellent meal while spending time on the park grounds. The café opened for the first time on Declaration Day, serving fried chicken, steak and fish dinners. The New Blue Line Café, which overlooked Lake Minnetonka, has long been a favorite spot in Excelsior, and it was known for its excellent food.

The park opened for its first preseason opening the evening of April 30, with rides given a new coat of paint for the season. The Stratosphere Man was the first big free act of the 1938 season. Arzeno E. Selden, from Lansing, Michigan, was a circus aerial artist who had worked with the circus until his wife was killed during a circus accident. That was when Selden developed his high pole trapeze act, the Stratosphere Man. The act consisted of a trapeze and swaying pole set at a height of ninety feet in the air, with a two-inch tube pole extended another forty feet. The Stratosphere Man swung freely from side to side in acrobatic positions, creating sensations that left his audiences breathless. The finale was a ninety-foot "Slide for Life" down a long wire with his head in a sling that was equipped with a brake. Park management brought him back due to requests from hundreds of patrons who saw him perform back in 1933.

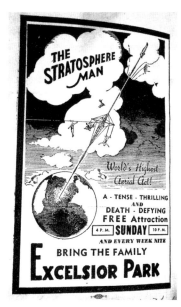

Advertisement touting the appearance of the Stratosphere Man, a free attraction. The park survived during the Great Depression due to free attractions. *Author's photo with permission from the Excelsior–Lake Minnetonka Historical Society.*

The park instituted a new dance policy for the 1938 season in the ballroom that was to provide new and better bands every two weeks, with big-name bands in person during the summer in one-night engagements.

Excelsior Park played host to the participants in the *Minneapolis Journal*'s All-American Soap Box Derby as they arrived at the park by a chartered bus on the Friday in July before the 1938 Soap Box Derby race for an afternoon of fun and free eats. Each boy was given fifteen tickets for everything

in the park, and at the close of the afternoon, he was provided a meal of Witt's Sauswiches and bottles of Stilicious chocolate milk.

More than two thousand youngsters from Twin Cities orphanages and settlement houses took a train ride out to Excelsior in August 1938. Two train loads of youngsters were brought to the park, which was turned over to them for the day. A large picnic meal and free refreshments were served, and the children enjoyed a ride on the steamer *Minnetonka*. All rides were open for the orphans except for the roller coaster, which was thought to be too dangerous for the kids. Local celebrity Cedric Adams made a recording of the picnic.

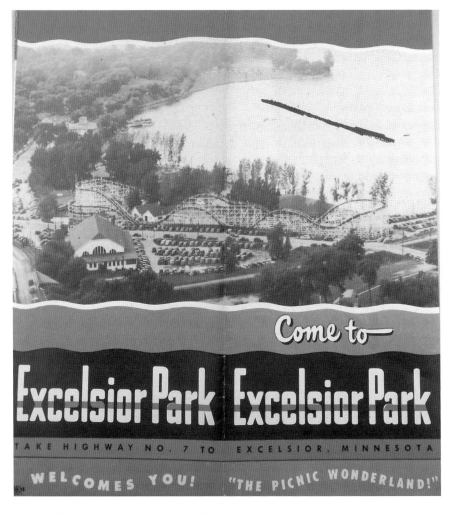

Excelsior Park brochure. *Author's private collection.*

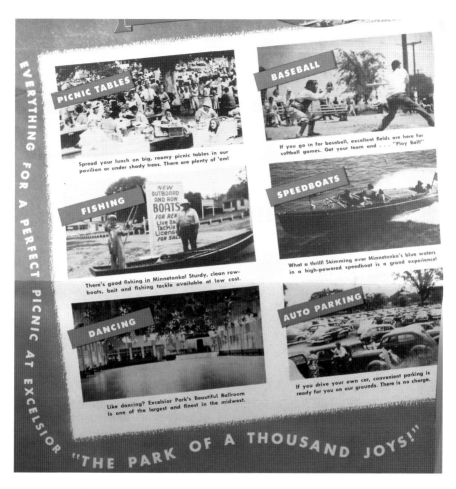

Brochure showing the attractions at the park. *Author's private collection.*

Later in August, Cedric Adams of the *Minneapolis Star* came back to the park to judge the Miss Minnetonka beauty contest. The winner then went on to the Miss Minnesota contest at Lynwood Park at Lynd, Minnesota, and the Miss Minnesota winner went on to Atlantic City for the Miss America contest. Assisting Cedric Adams in judging the contest were the mayors of the towns on Lake Minnetonka, Excelsior, Mound, Island Park and Wayzata.

Gould's Banjo Orchestra returned for another engagement at the park near the end of the season. The high point of the performance, according to press clippings, was the performance of little Miss Ann Bennett, who was the drum majorette of the band.

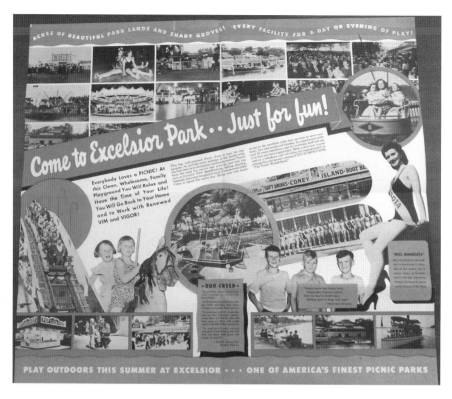

"Come to Excelsior—Just for Fun!" *Author's private collection.*

Captain Jack Payne and his famous high dive fire act also returned to the park this year. Payne's continual diving deafened him over time, so the park fired a rocket salute prior to his dive, letting Payne know that everything below was ready for him.

For Apple Day in 1938, the cost of all rides was five cents; the coaster and Funhouse charge was ten cents. The park officially closed for the 1938 season on Sunday night, September 18, but opened later that week to play host to the Postmasters Convention on September 22.

MAKING IT THROUGH THE WAR

World politics provided another ominous sign to the park's survival. With the German government becoming more aggressive, signs of possible military intervention were growing. The United States, a continent away, was trying to maintain its independence from the European fray. Involvement in a war would immediately affect the park in two crucial ways. The pool of young men who could be employees at the park would take a drastic cut, and it would also put a chokehold on roughly one-third of the target market for park patrons. Fortunately for the amusement industry, the 1941 operating season was fully completed before the United States was drawn into World War II due to the bombing of Pearl Harbor on December 7.

In fact, Excelsior Park's plans for a 1942 addition had already been finished prior to the bombing, so it was able to announce the addition of the flying scooters to its ride lineup for the 1942 season. For those readers unfamiliar with a flying scooter, the ride vehicle itself hangs from an arm that attaches to a center pole. Sails attached to the front of the ride vehicle permits a rider to swing in and out and up and down at great speeds. This new ride carried ten persons. With the addition of the flying scooters, Excelsior now had twelve rides in all. The beginning of the season was plagued by six weeks of intermittent rains that greatly affected park attendance. The park's attendance was also affected by the new wartime tire rationing the country was experiencing. Attendance by July was off by 20 percent, but per caps were 20 percent higher than 1941. The park by then was expecting that

Refreshment stand to the left of the park's east entrance. *Pearce Family Photographs, used with permission.*

1942 would top 1941, which was the park's best season since the Depression. Excelsior purchased four acres of land across from the resort to increase parking by 100 percent. The park owned all concessions at the park except for the speedboats, which were operated by Holden & Lamont, and the popcorn stands, which were owned by John Romas.

The well-known Lawrence Welk and His Orchestra appeared at the ballroom for one night only on June 16. Jane Walton was the featured singer, and Jerry Burke was on the electric organ. Welk stopped at the park after a long-running stand in Chicago. This visit followed up on Welk's two visits to the park in 1941. His return 1941 engagement on July 23 drew 814 people to the park despite one-hundred-degree heat. The North Dakota bandleader was a favorite of the Excelsior dancers.

An estimated twenty-nine thousand visitors came to Excelsior during the Fourth of July holiday, as the park put on another huge holiday fireworks display. Rains scattered the holiday crowd early in the afternoon on the fourth, but the weather cleared nicely in time for the display. Traffic to and from Excelsior during the holiday was aided by the new overhead entrance to the town of Excelsior.

Riding the country's fervor of patriotism, on Thursday, August 20, 1942, the park hosted an Army-Navy Benefit Day at the park. The entire day's receipts, $1,626.94, were turned over to the Army Emergency Fund and

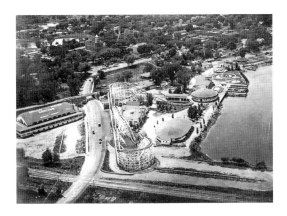

An aerial photo of Excelsior Park from the east. *Pearce Family Photographs, used with permission.*

the Navy Relief Society. Free entertainment was provided for park guests all day long. On the grounds of the park, various war exhibits were on display. The Army Band paraded through the park, and the U.S. Naval Aviation Orchestra held a concert. War bonds and stamps were on display, and a gigantic free fireworks show was held. An army-navy ball at the ballroom concluded the day's entertainment.

According to *Billboard* magazine, a big last-minute business spurt enabled the park's 1942 season to equal 1941's attendance. More than ten thousand people came to the park on Labor Day to take part in a picnic sponsored by the Minneapolis Shopping News. Park manager Joe Colihan attributed the great end of season push to management putting on a whirlwind drive to offset the weather. Poor weather had been dogging the park all season, said Colihan. In fact, he added, the weather was the worst he'd ever experienced in his years in the amusement business.

The annual combined Harvest and Kiddies Day was the feature festivity for the park on Labor Day weekend 1942. Free thrill rides were given to all families together with reduced rates on other rides and amusements in the park by clipping out the Excelsior park ad in the paper. Free coffee was given to families who brought their own picnic baskets, their own containers and their own sugar. Free use of the picnic kitchen and pavilion was available for those who desired to enjoy a day's outing before the start of the school term. As had been the custom at the park festival on Labor Day, a beautiful spotted pony was given away along with twenty-five other gifts.

The beginning of the 1943 season started poorly for the park. Poor weather and transportation difficulties combined with young men who were away serving in the armed services, reducing business. When the weekends came, the park was hit hard by rainy and "beating" weather. Excelsior began

its nineteenth season of full-time operation on Memorial Day with a large attendance on hand during the day, but by nightfall, the heavens had broken loose and rains drove all the fun-seekers to cover.

Excelsior Park inaugurated a new ballroom policy at the beginning of the season where the dance hall was in operation five nights a week instead of the usual seven, with just one band performing each night throughout the season. The new policy meant that the ballroom was dark on Monday and Tuesday evenings for the first time since the park opened in 1925.

One of the park's letterheads. *Author's photo with permission from the Excelsior–Lake Minnetonka Historical Society.*

As for park attendance through 1943, 75 percent to 80 percent of the crowds going to Excelsior Park were from the Twin Cities area. Sundays afforded local farmers and people from small towns from the region to come to the park. The average stay of each visitor at that time was two to three hours. For the park to operate, four hundred kilowatts of electricity were needed each day. Although bus lines from the Twin Cities operated within a short distance of the park, any form of mass transportation from other surrounding areas to the park was poor. However, the park's efforts to obtain school and club picnics were netting pretty fair results, although annual picnics of several suburban community organizations were down because of the transportation difficulties. Joe Colihan told *Billboard* that while attendance was down in 1943, per capita spending by park patrons had been noticeably increased, although not enough to offset the drop in attendance. Also, for the first time since the park opened, it had no free act performing for the Fourth of July of that season.

On June 25, 1943, six people were injured when a speedboat operated by Excelsior Amusement Park and driven by T.S. Rustad of Excelsior collided with a power boat owned and operated by L.C. Rademacher of Minneapolis. The collision occurred just off the Blue Line docks on Lake Minnetonka, sending all six injured people to local hospitals. According to witnesses, Rademacher's power boat hit the Excelsior Park speedboat,

Park letterhead with hand-drawn scenes depicting park activities. *Author's photo with permission from the Excelsior–Lake Minnetonka Historical Society.*

shearing off the speedboat's rear end, or stern. Both boats sank immediately. The park's speedboat carried five passengers besides the driver. To assist in determining who was at fault for the collision, Rustad told authorities that his lights for the speedboat were shining brightly. To prove it, he took the deputies to the scene of the crash and showed them that the lights were still on, even though the craft was underwater. Rustad contended that Rademacher's boat was traveling without lights.

The park had scored a public relations coup earlier in 1943 when Excelsior Park was properly granted the Miss America contest franchise for Minnesota; the park would conduct its first contest as franchise holder in August. Ms. Florence Hunton—a business school student from Minneapolis who could sing, dance, act, twirl a drum majorette's baton or make a serious speech—was the winning contestant that year.

Trouble occurred at Excelsior Park in June 1944 when handbills that announced a competing commencement night dance were distributed at the Excelsior ballroom. Fights in the ballroom ensued, bringing sheriff's deputies to Rudy Shogran's office. The park swiftly asked that the man distributing the circulars be escorted from the park, but a crowd gathered around to protest the move. During the protest, an eighteen-year-old said that he could buy beer at the ballroom despite the law saying that beer could not be sold to persons under twenty-one. He walked to the dance hall bar, flashed a draft card and came away with a bottle of beer. Deputies then had to make an arrest. Shogran, who had already left the park, was charged, but the case was dismissed. Waitress Clare Munson was also arrested and charged for selling beer to a minor. She denied the charge and stood trial before Judge Thomas L. Bergin. Miss Munson claimed that the youth showed a draft card indicating that he was twenty-one. Shogran told the press that a gang of rowdies had attached themselves to the ballroom after another Lake Minnetonka amusement center had closed. Shogran hinted to *Billboard*

magazine that the park might cut out beer sales entirely to avoid further difficulties such as this one.

Intrigue filled the 1944 Miss Minnesota contest held at the park. Siblings Patricia Cummings, a twenty-year-old former welder, and nineteen-year-old Miccela Cummings, her sister, were locked in a battle to see who was the most deserving girl in the family to be crowned Miss Minnesota. It turned out to be not as much of a drama as it could have been, as Patricia, a graduate of West High School and Minneapolis School of Business, was crowned the winner.

For the 1945 season, the park, responding to the request of many patrons who missed the Ferris wheel, purchased a new No. 12 Eli Wheel from Eli Bridge in Jacksonville, Illinois. The new wheel stood sixty-five feet high and had twelve cars. Eli Bridge is still known today for the Ferris wheels it manufactures. With the Ferris wheel addition, the park now had thirteen total rides according to a newspaper article.

Joe Colihan told *Billboard* magazine that manpower for the 1945 season at Excelsior Park was scarce but that with the help of many part-time

The Bud Strawn Orchestra, a popular ballroom draw, was photographed outside the St. Louis Park High School. *Author's photo with permission from the Excelsior–Lake Minnetonka Historical Society.*

Now Is The Time To Set The Date For Your Picnic

Dear Friend: This is a little reminder that we have not heard from you in reference to your picnic, and we are anxious that you have a good date to meet your requirements. We would be pleased to have you advise us if we may expect your group this season.

Please either write us at Excelsior Park, P.O. Box 396, Excelsior, Minnesota, or phone us at our Minneapolis office - MAin 2222, that we may help in making necessary arrangements for your outing.

We give your group or organization, reduced rates on the Rides - Amusements and Dancing. We can furnish your group a delightful picnic lunch - if desired.

Cordially yours,
EXCELSIOR PARK

Mpls. Office - Andrews Hotel Rudy Shogran

A picnic reminder postcard that Rudy Shogran used to book and promote the park's profitable picnic business. Rudy was a California resident whose home during the season was the Andrews Hotel. *Author's photo with permission from the Excelsior–Lake Minnetonka Historical Society.*

workers, the park should be able to operate like it did in 1944. The dance hall was scheduled to operate only on Friday and Saturday nights due to gas rationing but would feature the wonderful sounds of the Bud Strawn Orchestra again for the entire year. Charles E. Sampson once again was the park's refreshment manager.

Bucking rain and inclement weather since its opening of the 1945 season, Excelsior Park enjoyed big business on its weekends. Crowds were larger and spending more during this season than in past seasons.

Excelsior also recorded more school picnics with larger attendance than in previous years. The largest crowd ever to spend the holiday at the park turned out on July 4. Not since 1935 had there been such a crowd to see the fireworks display at night. Fireworks slated for July 3 had to be canceled due to heavy rains.

Excelsior staged its fifth annual Miss Minnesota contest on August 12, when seventy-five ladies competed for the honor of representing Minnesota at the Miss America Pageant in Atlantic City. The winner was Arlene Anderson, who ended up as the fourth runner-up at the Miss America Pageant.

In August 1945, the Second World War ended. This event had a monumental effect on the fortunes of not only Excelsior Park but also the

amusement industry in general. Soldiers returned home from the war held in both Europe and the Pacific and reconnected with the loved ones they left behind. New families were formed, and the new parents of these new families would be looking for places to entertain their children.

It was reported in September that Excelsior Park wrapped up its 1945 season with the highest gross business in the park's history. According to Joe Colihan, the gross at the park was up nearly 20 percent from the year before. He noted that both spending and attendance reached a new all-time peak. Several new park additions, like the new Ferris wheel, paid great dividends for the park. The dance hall drew huge crowds all season when the weather was good, and the park's refreshment stand was about 25 percent better than the year before.

Excelsior Park had always assumed that the Minnesota State Fair siphoned off some of its visitors in the end of August, as the state fair usually runs from the second-to-last Thursday in August until Labor Day, but that may not have been the case. In 1945, the State Fair Board decided not to hold a fair, but the park's attendance during those days were roughly equal to its attendance during the state fair span in 1944.

In December 1945, Clarence Peterson of Excelsior filed a lawsuit for $50,000 of damages in Hennepin County District Court on behalf of his son, Charles W., fifteen, against both the park and Arrowhead Fireworks Company. The complaint alleged that after an Arrowhead Fireworks display in the park back on July 4, several unexploded pieces of fireworks were given to Mr. Peterson's son by the agents of the park. The boy took them home, it was charged, and when he tried to fire the powder in a toy cannon, the cannon exploded and the boy lost his right hand and forearm. Named as defendants in the lawsuit were Fred W. Pearce & Company, as owners of the park, and J.J. Atol, Duluth, the head of the Arrowhead Fireworks Company. Since the case was held in the district court, its outcome is not readily available.

Highlights of the park's improvement plans for the 1946 season included a new ride known as the Silver Streak and the installation of a new public-address system. The Silver Streak was a flat, circular ride quite similar to the old Bayern Kurve that used to exist at Valleyfair Amusement Park in Shakopee. Other improvements for the season included redecorating the restaurant, planting three hundred trees, erecting a new workshop and removing the Walk-Thru house and installing games in its place.

Fourth of July attendance in 1946 was down from the previous season, but *Billboard* reported that Excelsior Park's attendance did not take a

noticeable hit from the Twin Cities' polio scare that happened during the summer of 1946. The park's attendance rebounded in September nevertheless, as it had its best Labor Day in park history.

The year 1947 saw the park beginning to stock up on rides that appealed to the younger crowd. The larger acquisition for the '47 season was a new miniature train from Dayton, Ohio, that could hold up to thirty-two passengers per ride. The train was powered by a diesel locomotive. The ride skirted the south shore of Lake Minnetonka from the picnic pavilion to a loop in front of the coaster and out over a portion of Lake Minnetonka. The route was two thousand feet. The ride's center rail was used on the way out and on the way back. It was large enough to accommodate both adults and children.

The park also installed two other kiddie rides: a Roto-Whip and an auto ride, for a total of $10,000. The kiddie auto ride was a circular ride with small automobiles, trucks and fire wagons propelled along a circular path. The vehicles were made of cast aluminum and rubber tires. The ride was powered with a one-horsepower electric motor and was illuminated. A canvas umbrella was suspended from the center pole. The Roto-Whip was also a circular ride, with eight upholstered ride vehicles. The ride attempted to mimic the motion of the larger Whip ride. A one-horsepower electric motor provided the power. These two rides were installed on the lakefront near the carrousel. Also new for the season was the Playland Arcade and two candy floss machines. In fact, according to a *Billboard* article, the only concessions rented out were popcorn and candy apples, to John Romas.

Early 1947 Excelsior Park attendance was off 20–25 percent according to *Billboard*. Business picked up in July due to exceptionally fine weather. The park's midsummer business was not affected much by Minnesota's anti-gambling crusade. All the games at Excelsior were games of skill, so the park didn't have anything to worry about. Card raffles had been outlawed by then governor Luther W. Youngdahl, who spearheaded the anti-gambling drive and by the state's attorney general, J.A.A. Burnquist.

Wednesday, August 6, 1947, began like any other day at the park. The people were taking time out of their busy day to go to the park to have fun. One group of young people planned to have fun at the park after they had met the day before while undergoing physical exams for the army reserve at Fort Snelling. James Hohman, originally from St. Cloud, and his friend George Savig met Ralph Hollamborg from Brainerd at the induction center at Fort Snelling. The three young men were joined by three young ladies—

Janet Jones, Betty McGowan and Lillian Mullen—for a group outing of fun at Excelsior. Miss Jones, who like George Savig had worked at Northern States Power, had invited the other two women to join her and the three men. The group had intended to go to the Excelsior dance hall but found out it was closed and went for a roller coaster ride instead. As the "King of the Midway," the park's roller coaster was a required ride for most park visitors. George Savig and Miss Jones hopped in the front seat of the roller coaster train, while Hohman and Miss McGowan sat directly behind them. Hollamborg and Miss Mullen took the very last seats of the coaster train.

While the group was enjoying a thrilling ride on the roller coaster, their night soon turned tragic. Hohman said, "Everything happened so quickly that it is impossible to tell exactly what happened. At the [coaster's] highest point before the last dip, the car seemed to lurch a little and it seemed as though both Miss Jones and George [Savig] would go out over the front. George seemed to lurch ahead of Miss Jones as though to pull her back, then it looked as though she sank back and he went over."

George Savig, twenty-one, from St. Cloud, Minnesota, fell from the front of the roller coaster train, and his body was hurtled through the structure of the roller coaster to the ground twenty-five feet below. When he was found, it was discovered that Savig's left arm had been torn off above the elbow, and he may have suffered a possible skull fracture, head cuts and other injuries suffered during the fall. Reverend Thomas Cushen was quickly contacted, and he administered last rites to Savig before a Smith Emergency ambulance rushed him to St. Mary's Hospital in Minneapolis. George Savig died at 10:55 p.m., shortly after he had been taken to the hospital. George had moved to Minneapolis about six weeks before the accident. Miss Jones was too much in shock that night to tell deputy sheriffs what had happened.

Although he had not immediately obtained a full account of the accident, park manager Fred Clapp declared that it was impossible to get out of a roller coaster seat without standing up. Joe Colihan stated, "Never in the history of roller coasting has anyone been thrown out of a car."

The following day, an investigation into the accident was undertaken. George Savig's riding companion, Janet Jones was adamant that he was not standing up when the accident happened. Jones recalled that the cars were climbing to the peak, just before the final drop, when she became frightened and started to scream. She stated, "When we hit the top of the peak there was a turn in the tracks and the car gave a jerk. George picked that split second to lean forward and try to put his hands on my shoulders

to reassure me. He went over the side. It happened so fast I'm not certain yet just what happened."

For Miss McGowan, it was her first ride on the roller coaster. She was "too concerned with myself to notice much else around me, but I know that [Savig] wasn't standing up because I could not have helped seeing if he had been." Miss Mullen said that she was unaware that Savig had fallen out until they reached the end of the ride because her view was blocked by other passengers. Both women said that a strong forward lurch was experienced by the riders when the train reached the top of the incline, but they stayed in their seats by holding tightly to the lap bar. George Savig's missing arm was found by deputy sheriffs the next morning lying on top of a canopy leading into the park, a full one hundred feet from the point of impact.

The following day, Fred Clapp still had no idea how the accident occurred, but he insisted that no one could be thrown from one of the cars unless he stood up. He pointed out that there was a sign warning passengers as they entered the coaster station to remain in their seats throughout the ride. The park found no problems with the equipment and noted that the coaster cars and the track itself undergo daily inspections by the park's maintenance team before the ride begins operation for the day. The Village of Excelsior itself had no department that performed an inspection of the amusement rides, and village deputy recorder at the time, Victor Arnold, said that he knew of no one who would be better qualified to make the inspection than the men who operate the ride.

Early the next year, Excelsior Park Company was named a defendant in an $11,000 lawsuit filed in Hennepin County District Court by Oscar S. Savig, George's father. The complaint charged that the park was negligent in the August 6 death of George, who plunged to his death from a car on the roller coaster while it was in motion. An investigation by county law officials at the time exonerated the park of any blame. Once again, since this case was pursued in district court, and the case was not appealed to the Minnesota Court of Appeals, records from the case are not readily available.

According to published reports in *Billboard*, the park's business by June 1948 was off 15 percent. The park's picnic season got off to slower start because Minneapolis schools closed one week later than usual due to a school strike the previous winter. Business picked up when Cedric Adams's two shows, including *Stairway to Stardom*, began broadcasting from the park pavilion. Fred Pearce was in town for nearly a month supervising

the rebuilding of the pavilion stage, which was enlarged by four times compared to the original. A dressing room and radio control room were installed. New games on the park's midway this year were the balloon race, huckley-buck and hoopla. The park also installed new streamlined Whip cars. Excelsior Park now had thirteen rides, the Funhouse and the Mystery House, eleven games, one novelty game and seven refreshment stands. Outside concessions still included candy apples and popcorn, from John Romas, and four speedboats operated by Holden and Jensen. Included in the management team that year was Muriel Baughn, who managed games, and the park had 125 people on its payroll.

In September 1948, Minnesota became home to the reigning Miss America. Her name was Beatrice Bella Shopp, known to most as "BeBe." Ms. Shopp was crowned Miss Minnesota at the annual contest, held at Excelsior Park on August 22, and was the first Miss America to be crowned in an evening dress after the pageant was resurrected in 1935. The park began holding the Miss Minnesota pageant in 1941. Each year up to this point, the Minnesota contestant had placed better. Starting in 1944, the Miss Minnesota contestant placed in the pageant's top ten. In successive years, Miss Minnesota placed ninth, seventh, fourth and then second before BeBe Shopp became Miss America. The Miss America runner-up in 1947 was Minneapolis's Elaine Campbell.

Miss Shopp's selection was a personal triumph for Rudy Shogran, the park's public relations man. When plans for the Miss Minnesota contest were being discussed among the park's management earlier in the year, Shogran had a hard time convincing the skeptical Joe Colihan and Bill Clapp that the contest was worth sponsoring. Shogran asked for one more chance for the park to sponsor a winner.

A press pass for Rudy Shogran at the Miss America contest held at Atlantic Beach. *Author's photo with permission from the Excelsior–Lake Minnetonka Historical Society.*

Shogran pinned his hopes on BeBe Shopp. Shopp was in the 1947 Miss Minnesota contest, but based on her age at the time, seventeen, she was not eligible to be considered as a contestant for the title. Using his well-developed sales skills, Rudy was able to convince BeBe and her parents to enter the 1948 contest. Shopp extended much praise to Shogran and Excelsior Park for the help they provided her during the whole contest experience. She told the

press about the endless hours of training Shogran furnished to her after she became Miss Minnesota to help her win the Miss America crown. She had speech classes, modeling hints, makeup lessons and constant practice on the vibraharp, the instrument on which Ms. Shopp performed during the pageant—everything that was needed for her to compete for the crown.

For one of the few times during its history, Excelsior Park reopened after it was closed for the season. For one night on Wednesday, September 15, at 7:00 p.m., the park welcomed home the new Miss America. A parade formed near the Minneapolis & St. Louis Railway depot in Excelsior and went through the village out to the park. BeBe, who was wearing an orchid and holding two bouquets of flowers, was nearly crying as she was greeted by the large crowd that had gathered at the park. She quickly composed herself and sat down to her vibraharp to perform the musical numbers that won her the talent contest at the Miss America pageant in Atlantic City, "Clair de Lune" and "Caprice Viennese." The crowd that turned out at Excelsior Park was estimated to be five thousand people.

In a *Billboard* magazine article featuring park manager Joe Colihan in January 1949, the park co-manager said that BeBe Shopp's crowning as Miss America compensated the park for its seven years of hard work in sponsoring the Miss Minnesota pageant. Colihan said it was a great thrill for the park's management team and a highlight of his promotions career.

The new picnic gardens built at the park for the 1949 season and designed by Excelsior Park's owner, Fred W. Pearce, proved to be a hit, and picnic business for the season was running ahead of the year before. Joe Colihan, park manager, reported that more than two hundred organized picnics had been booked for the season. The Picnic Gardens, a sixty-foot-square building, occupied the old parking lot at the northeast end of the park. A grove for picnickers was made in the area adjoining the building that had a barbeque broiler, picnic stoves and a beverage stand and was enclosed by a fence.

But the season for the park started slowly, as Memorial Day business was down 25 percent despite ideal weather and a sky full of colors both Sunday and Monday night thanks to two fireworks shows supplied by Arrowhead Fireworks. Early ballroom business also was down compared to 1948, although the drop wasn't as bad as at the park. Following up on BeBe Shopp's Miss America title, the park held a special send-off event on July 2 for Miss Shopp for her European tour. Excelsior Park still designated one night each year for Twin Cities and suburban high school outing, now known as spring jamboree. The attendance at this event has

grown from one hundred at its inception to ten thousand attendees the last two years.

After about two-thirds of the season, the park was still running about 20–25 percent off the previous year's business. Spending was down on all the rides, stands and other entertainment that the park offered. Even though it was the park's twenty-fifth anniversary, promotion of that fact did not help to bring in more customers. The Fourth of July holiday, ordinarily one of the best days of the season, was down nearly 30 percent. Management believed that the stifling heat in the Twin Cities during the holiday kept customers away.

For the second year, the Excelsior Park pavilion was the site of WCCO's Saturday night broadcasts. Joe Colihan reported to *Billboard* that the radio show promotion was paying dividends that season. "The entire promotion works out well for all concerned," he said. The radio personnel practically were guaranteed a large studio audience, and the park was provided a large group of spenders early and late. The only business curtailed during the broadcast was the operation of the miniature train. Because it ran so close to the radio building, it was necessary for the park to shut it down during the broadcast.

The radio shows were staged from the picnic pavilion in the park. This building was open on all sides and was located on the shores of Lake Minnetonka. The pavilion seated about 2,500 persons, and another 1,000 could be accommodated around the outside of the building. All told, five shows were broadcast every Saturday, the first starting at 5:30 p.m. and the final show being staged at 8:00 p.m. All shows were sponsored by commercial firms, and announcers frequently mentioned on each show that the broadcast was coming directly from Excelsior Park. Two of the shows were transcribed, while three were "live" broadcasts.

Featured on the shows were personalities from WCCO such as Cedric Adams, columnist and newscaster Bob De Haven, Sally Foster, Clellan Card, Tonny Grise, Ramona Gerhard and Wally Olsen's band. A guest star was included almost every Saturday night. Adams conducted two talent contests, Bob De Haven emceed two shows and both barn dance sessions and Card had a musical session with Tony Grise as the featured singer. Ramona Gerhard presided at the Hammond organ.

The Miss Minnesota contest that year was televised for the first time in its history on local television station KSTP-TV. Gloria Burkhart, the contestant who won the Miss Minnesota title in 1949, was a friend of BeBe Shopp's. She went on to finish in the top fifteen at the Miss America pageant.

Despite the fact that ice did not come off Lake Minnetonka until May 2 during the spring of 1950, school business had been outstanding for the park through June. Two hundred school picnics had been booked for the early season, including schools from North Dakota, Wisconsin and Iowa. The seventeen rides then at the park, ten games, Funhouse, Glasshouse and six refreshments stands had all been refurbished. All of these stands—except for the caramel apples and candy stand, operated by John Romas—were owned by the park. Food items added at the park for 1950 included waffle ice cream, sandwiches, an automatic donut machine stand and a milk bar, which had been doing good business when the weather was okay.

In June 1950, about six hundred members, family and friends attended the twenty-fifth annual picnic of the Soo Line Employee's Association. In attendance was Mr. McNamara, president of Soo Line, and he just had to have his picture taken with the park train during the picnic.

With a packed house, a skunk found its way into the pavilion on August 10 during the Miss Minnesota preliminaries that season. Soon both women and men were jumping on chairs and benches to get out of the skunk's way. Rudy Shogran had no idea what was happening until someone yelled, "Skunk!"

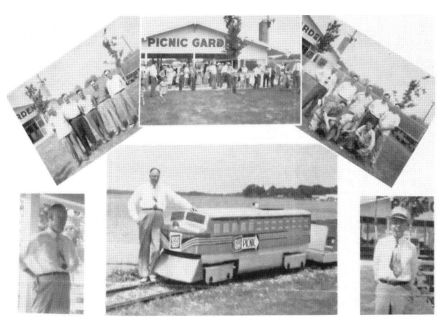

Soo Line Company picnic at the park, as depicted in the company's newsletter. *Author's photo with permission from the Excelsior–Lake Minnetonka Historical Society.*

An ad by Senator Thye to be placed in the Miss Minnesota contest program. *Author's photo with permission from the Excelsior–Lake Minnetonka Historical Society.*

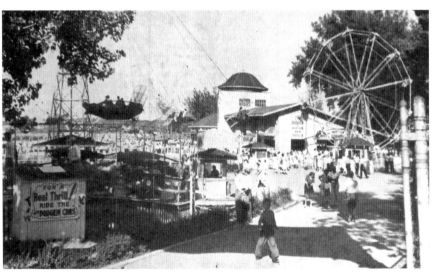

A view of the park from the west entrance in the 1950s. *Author's photo with permission from the Excelsior–Lake Minnetonka Historical Society.*

Of course, Rudy was a little scared at the prospect of having to pay for new clothes for thousands of park patrons. So, the band began to play, and a little while later, calm was restored; the odor had left, and the contest continued. The following weekend, eighteen-year-old Jeanne Traun, a vocalist from Minneapolis, was named Miss Minnesota for 1950.

Excelsior's Third and Fourth of July 1950 were on par with 1948 activity. The previous year's Fourth of July came in the middle of a heat wave, but weather was good in 1950. The park was fortunate to land the General Mills company picnic that year, and nine thousand employees and their families attended the outing in August.

By 1950, the peak age for polio incidence in the United States had shifted from infants to children aged five to nine years, and about one-third of the cases were reported in persons over fifteen years of age. However, the rate of paralysis and death due to polio infection also increased during this time. Thankfully, Excelsior's attendance was only minimally affected by the public's polio concerns.

New for the 1951 season were parking lots that could accommodate five hundred additional automobiles, according to the *Minneapolis News*. The park also landed the 3M annual picnic, with an attendance of twenty thousand people.

Carole Wick, an eighteen-year-old blue-eyed brunette from Duluth, was crowned Miss Minnesota of 1952. Carole stood five feet, three inches and was the most diminutive Miss Minnesota in quite a few years. Arlene Anderson (Miss Minnesota, 1945) and Elaine Campbell (Miss Minnesota, 1947) were also smaller contestants. Miss Wick was ranked fifteenth out of four hundred students in her graduating class and was a cheerleader at Duluth Central High School.

KIDDIELANDS AND DISNEYLAND AFFECT THE PARK

The new families established after the return of World War II soldiers from overseas increased the demand for new ways to entertain the young children of these families. This demand spawned a new niche in the outdoor entertainment industry: the Kiddieland. Kiddieland locations contained either a lineup of miniature rides for children or a land based on fairytales. One of the earliest Kiddielands was founded in Melrose Park, Illinois, in 1929.

To cater to these younger children and provide the type of entertainment these families might find at a Kiddieland, Excelsior Park in May 1952 created a kiddie section of the park aimed at providing fun to all children. Concentrated in the new kiddie development were a miniature Whip, autos, railroad and merry-go-round plus new equipment like a kiddie boat ride and a hand car. According to Joe Colihan, the park's plan was to offer the kiddie rides on a combination moppet ticket, a price that had yet to be set. In addition, Shogran was out drumming up birthday parties for the children. Specially built picnic tables and benches were being constructed for the area. For the birthday parties, the park furnished the cakes, tablecloths, prizes, novelty hats and similar souvenirs. This area reflected the philosophy of the park's management at the time that Kiddielands were a distinct source of competition to the park—that is why kiddie areas had become an important feature to an existing park. Despite these park additions in 1952, according to *Billboard*, Excelsior Park's 1952 business was on par with 1951.

The future of not just Excelsior Park but also the whole amusement industry was soon to be forever changed. Walt Disney, a known movie executive who made mainly animated films, was working on a different type of amusement park. On one stormy November night in 1953, in a smoke-filled hotel room at the Drake Hotel in Chicago, seven men gathered with Cuban cigars, caviar and an entire case of Chivas Regal. It was an evening during the annual meeting of the National Association of Parks Pools and Beaches, the forerunner to today's International Association of Amusement Parks and Attractions. Three of the men represented Mr. Walt Disney, who knew little about the outdoor amusement business: Harrison "Buzz" Price, a research statistician from Stanford Research Institute, and Richard "Dick" Irvine and Nat Weinkoff, both employees of Mr. Disney. The other four men in the room represented the most experienced, successful and respected owners and operators of amusement parks existing at that time in the United States. They were William Schmitt, owner of Riverview Park in Chicago; Harry Batt of Pontchartrain Beach Park in New Orleans; Ed Schott of Coney Island in Cincinnati, Ohio; and George Whitney of Playland at the Beach in San Francisco.

According to Buzz Price's recollection as laid out in his book *Walt's Revolution by the Numbers*, the three Disney representatives unrolled a bird's-eye master plan of a proposed park, and they stuck it to the wall with masking tape, stood back and invited comments from the four park representatives. These comments represented their understanding of the park business as it then currently existed. They told Disney's representatives:

1. All the proven money makers are conspicuously missing from Disney's map: no roller coaster, no Ferris wheel, no Shoot-the-Chute, no Tunnel of Love, no hot dog carts and no beer. Worst of all, Disney included no carnival midway games. Without barkers along the midway to sell the sideshows, people won't pay to go in to see the shows.

2. Custom rides will never work. They cost too much and will be constantly breaking down, resulting in reduced total ride capacity and angry customers. Only stock, off-the-shelf rides are cheap enough and reliable enough to perform for your customers, as the public would not know the difference nor would it care.

3. Most of Disney's proposed park produces no revenue, but it's going to be very expensive to build and maintain. Things like the castle and the pirate ship are cute, but they aren't rides, so there isn't any economic reason to build them.

4. Town square is loaded with things that don't produce revenue, like the square and the town hall for the fire department.

5. The proposed horse cars, the horseless carriages and the western wagon rides down Main Street have such small capacity and cost so much to run that they will lose money even if they run full all the time.

6. You can't operate an amusement park year round; 120 days per year is the best you can do.

7. Walt's design only has one entrance, which would create a terrible bottleneck. Traditional wisdom dictates entrances on all sides for closer parking and easier access for the customers.

8. You'll lose money providing all those design details and nice finishes. The people are going to destroy the grounds and vandalize the ride vehicles no matter what you do.

9. Disney's ideas about cleanliness and great landscape maintenance are economic suicide. He'll lose his shirt by overspending on things that the customers never really notice.

10. Modern mid-twentieth century amusement park management theory dictates the following: Build it cheap and then control your costs. Employment theory is similar: Pay your employees the least you can and then ride them hard and get ready to fire them because they will steal from you.

The bottom line, according to the park representatives, was that Disney's park idea was just too expensive to build and too expensive to operate. They told Disney to stick to the movies and let the park professionals operate amusement parks, yet in a short fifteen-year timespan from that meeting, three of the four park representatives were no longer in operation.

According to Disney's economic guru and amusement industry legend, Harrison "Buzz" Price, "Before Walt [Disney] came along, the entire industry was getting one dollar per capita. The main thing that Walt did was to figure out how to get the profit per person up to $4.50 in the very first year. And by the second year [Disney was] up to 6 dollars. The rest of the industry was astonished."

How did Disney do this? Well, it was very simple. It comes down to stay time. Before Disney, the stay time at an average amusement park like Excelsior was less than two hours. But Disney created an environment with an ambiance that was so refreshing and pleasant that the stay time went up to an unheard-of seven hours. And because the stay time went up, the

per capitas on food, retail and ride tickets went up. And the place was an attraction in itself, so he could charge people just to get in to the park, which wasn't done elsewhere. While the theming, landscaping and entertainment did not bring Disney an immediate return, it resulted in turning Disney's vision into a revolutionary, new and different income profile not previously seen in the industry.

Disney's vision and planning revolved around the customer experience. He made the customer want to spend time at his park. Disney and his storytellers beckoned the guest to explore and spend time in their world. The visit started at a familiar place, Main Street. Through the use of forced-perspective building, guests were drawn down the street toward the castle. To make Main Street even more familiar, Disney and his employees utilized the scent of vanilla to make one at ease.

There were two other things about the planning that also seem especially important, and each involves putting the guests' experience first: Disney planned the circulation patterns first. That's the place where the people walk. They planned that as a top priority. Up to that point, designers usually focused on the positive space (the thing being built) rather than the negative space (the place where people will be). And he planned every attraction from the perspective of the guest rather than the operator or the manager. Walt focused on the people. Second and perhaps more importantly, Disneyland was the first major attraction planned by storytellers rather than engineers, architects, operators or curators. Walt Disney's Disneyland experiment was still one and a half years from becoming reality, though.

While Excelsior management may not have had the foresight into this new version of outdoor amusement structure, what it did have going for it was that management had been keeping up with the advance of the new communication medium: television. It partnered with a number of the local television stations to have special attendance days and special appearances of personalities. I can only assume that management drew on its profitable use of radio personalities at the park and transferred that experience to TV personalities. One of these special appearances occurred in July 1954, when the park lured cowboy hero Hopalong Cassidy to arrive in town for a two-day visit to Excelsior Park. He flew into the airport in St. Paul to a celebrity welcome. On Saturday, July 10, Hopalong performed two shows at the park, one at 1:30 p.m. and the other at 3:30 p.m., and he stuck around to sign autographs. All one needed to do was to tear off the Hopalong Cassidy cover of the July 9 issue of *TV Guide*. That was your ticket, and it admitted two people and also included some free ride tickets. The other

The 1956 Miss Minnesota Universe contest program cover. *Author's photo with permission from the Excelsior–Lake Minnetonka Historical Society.*

thing that Pearce parks were great at was marketing to group outings. Just a month after Hopalong Cassidy was at the park, Excelsior Park played host to Honeywell's annual picnic, which brought with it an estimated crowd of eighteen thousand people.

In August 1954, Excelsior Park still had a beauty pageant, but it was no longer the Miss Minnesota, but rather the Miss Minnesota USA. The executive director of Miss America explained in a letter to Rudy Shogran in November 1953 that the Miss America pageant wanted to have more statewide coverage of contestants for the Minnesota pageant, but such a larger pageant commitment was not something that interested Fred Pearce back in Detroit. For that reason, the executive director of the pageant took the Miss Minnesota pageant franchise away from Excelsior Park.

Excelsior Park began the 1955 season by introducing a new marketing slogan, "Picnic Wonderland," but later in the season, the embodiment of a real revolution of the amusement industry debuted. On July 17, 1955, television and movie mogul Walt Disney opened his new amusement park, Disneyland, in Anaheim, California. The park was divided into certain themed areas: Main Street, Tomorrowland, Fantasyland and Adventureland. While the park drew an inordinate number of guests, and Walt Disney was able to promote his new attraction on his own nationally televised show, as mentioned earlier, the park flew against the conventional wisdom of the amusement park operators at the time.

While the opening of Disneyland and the revolution to the industry it represented was not necessarily fatal to Excelsior Park's existence, the well-entrenched park management during this period misdiagnosed the impact and longevity that Disneyland would exert. According to a *Billboard* article in April 1959, Joe Colihan noted that he felt that Disneyland was like a World's Fair, and he did not believe that it would have any effect on the standard amusement park layouts any more than the Chicago and New York World's Fairs did some years earlier.

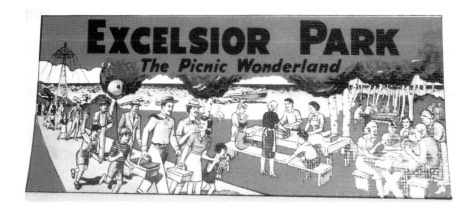

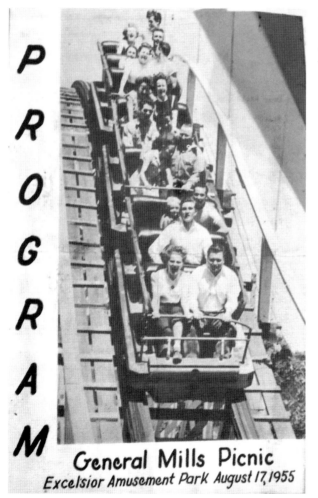

Above: "The Picnic Wonderland." *Author's photo with permission from the Excelsior–Lake Minnetonka Historical Society.*

Left: Roller coaster cars as placed on the General Mills picnic program. *Author's photo with permission from the Excelsior–Lake Minnetonka Historical Society.*

Fred Pearce enjoying himself on a handcar. *Pearce Family Photographs, used with permission.*

Excelsior Park continued to develop the park as it had in the past. New for the 1956 season was a children's Sky Fighter ride along with a picnic kitchen equipped to assist serving the large crowds that the park hosted. The project to finish black-topping the grounds was completed this year after about two-thirds of the park grounds were completed in the fall of 1955.

During the late 1950s, the park tried putting on a ten-cent gate charge, figuring to use the money to buy free acts for the park, but that experiment lasted about two weeks—the public proved to the park management that it wanted Excelsior Park to be a free park with free parking.

After more than twenty-five years of the same management team in place at the park, Excelsior Park management was forced to change for the 1957 season after the death of its longtime director of promotion, advertising and group bookings, Rudy Shogran. In the spring of 1957, Ray Colihan, son of park manager Joe Colihan, had been named to succeed Shogran. Shogran and the elder Colihan began work at Excelsior on the same day in 1930. Ray Colihan worked for Shogran before spending a year and a half with the United States Army in Japan. Upon his return, he became the manager of the 7-HI Drive-in Theater and manager of an indoor theater in St. Paul. Ray was introduced to working at the park when he was about twelve years old, working as a coat check at the ballroom, and in high school, he operated the Ferris wheel and did other odd jobs at the park.

On Labor Day 1957, Excelsior Park debuted a new ride from Eli Bridge called the Scrambler. The Scrambler has been described at that time in the

industry as the first successful new amusement ride in the last fifteen years. This new ride continued to be marketed as a new ride for the 1958 off season, while a crew of three people kept busy repairing and painting the twenty-one rides and walk-through attractions at the park, as well as the games, restaurants and other things. Meanwhile, Ray Colihan remained busy setting up annual school, corporate and church picnics at the park.

In August 1959, the park's founder and steady hand, Fred W. Pearce, passed away, and his corporation, Fred W. Pearce & Company, became owned by Fred's oldest son, Fred Pearce Jr., and his oldest daughter, Ethel MacMahon.

In 1960, Excelsior Amusement Park celebrated its thirty-fifth anniversary. New at the park that season was Hot Rods, which were six-foot-long midget sports cars powered by five-horsepower engines that the patrons could run on a 250-foot track. The ride was imported from Germany. The park also remodeled the Funhouse and renamed it Axel's Laff House, which featured outside the Funhouse an animated figure of the then famous Twin Cities television personality, Axel, with a special recording of Axel's voice. Axel

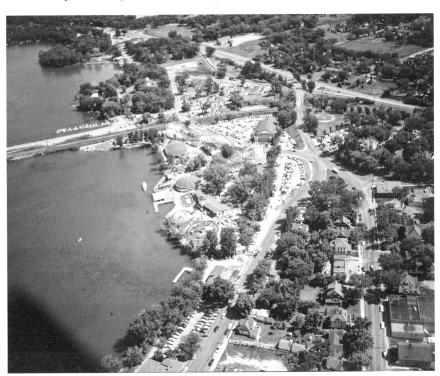

An aerial view of the park from the west. *Pearce Family Photographs, used with permission.*

appeared on WCCO-TV at that time. Also new in 1960 was a tie-in with Super Value Food stores. Every Tuesday throughout the summer was a bargain day. Super Value handled the advertising and distribution of special bargain tickets, which entitled the bearer to reduced rates of five cents on ten rides. As part of the park's celebration in August of the National Cerebral Palsy Benefit Days at Excelsior, world-renowned boxer Jack Dempsey visited the park. Labor Day 1960 turned out to be the park's second-best Labor Day, and the season as a whole was as good as 1959, which was a big year for Excelsior Park.

The favorite rides of patrons to Excelsior Park remained pretty much the same each year. In 1960, the roller coaster was still first, with some 120,000 riders. Following in order of ticket sales were the Funhouse, Dodgems, the Scrambler, the Ferris wheel and the merry-go-round.

Park co-manager Joe Colihan died suddenly on October 12, 1961, at his home at sixty-five years of age. Besides his position at the park, Joe was active in the Excelsior Chamber of Commerce and was a charter member of the Excelsior Rotary club. He is buried at the Resurrection Cemetery in Shorewood. The loss of Joe Colihan completed the near entire turnover of park management during a four-year period of time. The lone remaining manager was Fred Clapp, the uncle of the new shareholders of the company. What type of future was in store for Excelsior Park?

BIG REGGIE'S DANCELAND

D uring its operation, the ballroom next to Excelsior Park played host to such big-name bands as Lawrence Welk, Wayne King, the Everly Brothers, Del Shannon, Jan and Dean, Perry Como singing with the Ted Weems Orchestra, the Andrews Sisters, Jerry Lee Lewis, Conway Twitty, Brian Hyland ("Itsy Bitsy Teenie Weenie Yellow Polkadot Bikini," "Sealed with a Kiss"), Eddie Cochrane, the Belmonts, the Dave Cark Five, the Beach Boys and the Rolling Stones. The dance hall was the former roller skating rink that stood on the lake front at Tonka Bay. The building was purchased in the fall of 1922 by E. Armagost and J.E. McNiece, taken down in sections and reassembled in Excelsior. It was run as a dance hall and a roller skating rink for a few years until the ballroom became part of the amusement park in 1928. According to a May 4, 1923 article in the *Minnetonka Record*, the dancing floor was 75 by 150 feet, making it one of the largest in the northwest.

In 1959, Ray Colihan decided to open the ballroom on Tuesday nights for the teenage crowd; Friday night was for old-time music, and Saturday night was for Dixie. He soon found that the only night he made any money was the Tuesday nights with the young crowd.

In 1961, the dance pavilion was renamed Big Reggie's Danceland. It was opened for teen dances every Tuesday, Friday and Saturday from 7:00 p.m. to 12:00 a.m. Big Reggie's Danceland was run by Ray Colihan, aka "Big Reggie," and featured Big Reggie's Dance Band. (The rotund Colihan was named after a Reginald Van Gleason skit.) These teen dances gave way to

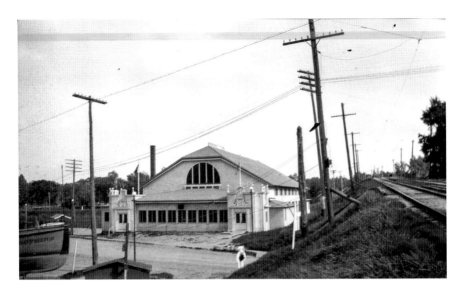

An early photo of the ballroom. *Pearce Family Photographs, used with permission.*

local "stomp" bands like the Trashmen and the Underbeats. The Underbeats remembered that Big Reggie always wanted to sing "Cotton Fields" with them on stage—apparently, he even made a record of his favorite song.

The park scheduled its annual Twin Cities High School night for May 3, 1963. It was the twenty-fourth annual special outing for high schoolers held at Excelsior. As always, the night consisted of some free rides, special entertainment, reduced ride rates and dancing during a full evening's program. The highlight for this night was the appearance of the popular California top forty record stars, the Beach Boys. It seems that Ray Colihan, while booking his entertainment for the park for the 1963 season back in February, had taken a gamble on booking the then little-known Beach Boys and agreed to pay them an appearance fee of $650. In March 1963, the Beach Boys released their second album, *Surfin' USA*, which eventually reached the number-two spot in *Billboard* magazine. By the time the Beach Boys appeared at the Excelsior Park in May, they had become popular, having a number-one record, "Surfin' Safari," on the local radio station WDGY, and their style of music, "surf music," had become a national phenomenon just as the twist had been a year earlier.

The Beach Boys were scheduled to headline a free stage show on the outdoor stage from 6:30 p.m. to 7:00 p.m. and then play for dancing at Danceland beginning at 8:30 p.m. While the park played host to eight thousand students

in 1962, it had no idea what was to come for this High School Night. People flocked from all over the Twin Cities to Excelsior to attend the Beach Boys' appearance at the park on Friday, May 3, 1963. Cars were stacked up along all of the roads leading to Excelsior as a result. Mike Love, in his book, *Good Vibrations: My Life as a Beach Boy*, wrote that "they [Big Reggie's Danceland] wouldn't sell any more tickets, so some fans came through a broken window in the bathroom. We played four 45-minutes sets, and between sets, Dennis and I stepped outside and saw headlights stacked up a mile down the road. 'Wow,' I said. 'This must have been how Elvis started.'"

It got so bad with the crowds that day, however, that Big Reggie almost lost his license. The police and fire department had to come out to take back control of a mob scene, complete with kids who couldn't get in trying to climb in through the windows and scaling the sides of the roller coaster. The best attendance estimates of that show placed the crowd somewhere close to 1,800, and the Beach Boys walked away with a $307 portion of the box-office receipts.

Big Reggie's Danceland had become a premier spot for many local acts that had sprung up in the Twin Cities in the '60s. Few people today realize it, but in the early '60s, the market for rock-and-roll music was quite regional in nature, so there was a greater chance that regional acts would hit it big locally. As a result local groups like the Castaways, the Underbeats and Gregory Dee and the Avantis all regularly stopped by Danceland. Jim Donna of the Castaways remembered one evening when Gregory Dee and the Avantis was playing the "Baldie Stomp." "The kids at Danceland started stomping on the dance floor, and the owner just freaked out. He thought the floor was going to collapse because it was literally bouncing up and down." According to a September 1974 article on Big Reggie, a ballroom manager ran across the street to the park to get Ray because the floor had caved in. Ray found out that the floor had dropped about four inches due to a sunk piling underneath the dance floor that needed to be shimmied. A big Danceland draw was Minneapolis's own the Trashmen, who ruled the Twin Cities airwaves from late 1963 until 1964. Trashman guitarist Tony Andreason recalled, "When you went to a place like Danceland, there was electricity in the air before the band went on....Once things kicked off, bands would feed off the intensity in the room, and [off] the dancer's requests."

As booking manager of Big Reggie's Danceland, Ray Colihan was always looking for talent he thought would attract visitors to Danceland. Early in 1964, the Beatles arrived in New York and shook up the popular music scene like no other band before it. Their appearance on *The Ed Sullivan Show* jump-started the American youth's curiosity for music bands from England

that were, in effect, reinterpreting classic American blues with a pop spin in an era known as the British Invasion. A variety of English bands boarded planes for the United States, affording booking managers of U.S. venues, like Colihan, an opportunity to book these bands, hoping that the American music audience would be enamored of their music by the time they got to a venue. Colihan hoped that he might be able to get lucky for a second year in a row when he decided to book a young up-and-coming British band, the Rolling Stones, while in the country on their first tour of the United States.

The Rolling Stones formed in 1962, and by the time of their first tour of the United States, they had incorporated American blues, rhythm and blues and '50s rock-and-roll into their shows. The Rolling Stones showed up at public appearances in everyday clothes and with long hair. Their manager, former publicist Andrew Loog Oldham, helped to promote the untamed image of the group. "Would you let your sister go out with a Rolling Stone?" became a provocative headline in England at that time. At Oldham's suggestion, the band members purposefully did not smile on the cover of their first album, *The Rolling Stones*, which was renamed in the United States as *England's Newest Hit-makers*. The single that the Rolling Stones released during the time of their first tour was a cover of Buddy Holly's "Not Fade Away" done with a Bo Diddley–style beat. The song on the back side was a cover of one of the Beatles' album compositions, "I Wanna Be Your Man." The single barely made a dent in the top one hundred U.S. charts, and the album was basically unknown in America at the time the Rolling Stones' first tour commenced.

The band's first tour began on June 5 in San Bernardino, California, after some press conferences in New York, and the California concertgoers knew all the songs. But the Rolling Stones found a different reception during the Midwest portion of that tour. The band had just recorded for the first time in the United States at the famed Chess Studios in Chicago for two days prior to their Excelsior stop. It was at Chess Studios where the group recorded its next single, "It's All Over Now," and another classic, "Time Is on My Side." The band members had an opportunity in Chicago to meet some of their idols, including Muddy Waters, Willie Dixon, Chuck Berry and Buddy Guy, and left Chicago after a Michigan Avenue press conference and headed on to Minneapolis for the Excelsior stop.

Reggie went to the airport in a limousine to pick up the group with his niece, Suanne Kreisel. She claimed that she didn't really care much to go:

> *I had my hair up in tin orange juice cans that I used for curlers, and had no make-up on.…When we got to the airport in this limo, Mick Jagger got*

in the car and rolled down the window and spit. I don't remember what he spit but I thought they were disgusting. We went to the Lincoln Dell [Deli] for lunch. The whole time I was thinking, "Hurry up and eat. I want to get out of here!" We were sitting at one table and they were at another. I could have reached out and touched them but I just wanted to get back to see my boyfriend. They had long hair, and they looked dirty even though they probably weren't.

Once they arrived in Minneapolis on June 12, the Rolling Stones made radio appearances early in the day, but Colihan did little other direct advertising of the concert except for a few mentions by Bill Diehl on WDGY. This lack of marketing by Colihan may have been from a fear of losing his license to operate Danceland if too many kids showed up at the event. But word of mouth advertising also failed to bring any of the group's fans who lived in the area.

Apparently, Colihan called Mike Waggoner of Mike Waggoner & the Bops about a week to ten days prior to the Rolling Stones concert. According to Mike, the Rolling Stones were very, very green, with no real U.S. hits at that time, and they played a lot of blues covers. Colihan wasn't sure what to expect of the Rolling Stones' appearance, so he asked if Mike Waggoner & the Bops would be on the bill so that he had a solid band just in case the Stones were not well received. Mike recalled that the Rolling Stones were very modest and quiet, exchanging polite greetings with him and his band.

Mike also noted that the Rolling Stones didn't arrive for the Excelsior show with all of their amps or equipment except for their guitars, as they used some of his band's backline gear and sound system. They borrowed a drum set (via Ray) from B Sharp as a part of the agreement. Mike also has a photo of Bill Wyman that also shows the band's PA speakers. According to Mike, the fact of the matter is that no one really knew about them, and they didn't seem to be a big deal. That is why there are very few pictures or specifics to rely on for history. In his autobiography, *Stone Alone*, Rolling Stone bassist Bill Wyman remembered that the Danceland audience "reaction was very similar to our first ballroom dates in England—curiosity and disbelief. They did, however, warm to us towards the end of our set."

After the concert, Timothy D. Kehr took the Stones back to the Twin Cities in his four-door '57 Chevy (yellow with a white top). Mick sat in front with Kehr, and in the back were Charlie Watts, Bill Wyman and the Stones' road manager, Ira Sidelle, a friend of Kehr's (which explains why they were in his car). "Some kids from town had gotten hold of some eggs and pelted

the car on the way out." Kehr took those in his car to Friar Tuck's on West Seventh Street in St. Paul, a drive-in restaurant (the others went straight to the hotel). "They had never seen a drive-in before, and ended up staying for two hours, ordering everything on the menu." Kehr remembered that they stayed at the Bloomington Motor Lodge by the airport. The band had a concert the following night in Omaha.

Colihan lost money on the $2,000 he paid the Stones. A $6 admission fee also kept the kids away in an era when tickets were generally $1.50. (After 10:00 p.m., tickets went to half price, and more people showed up.) In an interview, Colihan said that he booked the Stones about a month too early, before they were popular in the Twin Cities. The Stones had a few mild hits in the spring and summer of 1964, but their first top ten, "Time Is on My Side," wouldn't come until October.

One long-standing Rolling Stones legend, never refuted by any member of the Rolling Stones, concerned an incident that allegedly occurred during this Excelsior visit that inspired the group's songwriter and lead singer, Mick Jagger, to write one of the group's classic hits. Allegedly, Excelsior resident Jimmy Hutmaker, whom most people in town referred to as "Mister Jimmy," was at a local drugstore when Jagger came in to order a cherry cola but got a regular one instead. He complained about the mistake to Mr. Jimmy, who told Jagger, "You can't always get what you want." A song by that same name was released in 1969, and this story, known by Mick Jagger, has never been either affirmed or refuted. Hutmaker died in 2007.

According to Fred Pearce Jr., rock-and-roll got too tough, and Danceland wasn't keeping the family image that he wanted Excelsior Park to portray, so he made the decision to close it in May 1968. He also told the Excelsior city manager that his accounting records showed that he lost more money on the operation of the ballroom each year due to increasing costs. He decided that he would turn the park's ballroom into a storage facility, and the park ballroom was later used for boat storage.

Early Sunday morning on July 8, 1973, at 2:09 a.m., the fire alarm sounded at the Excelsior volunteer fire station. Chuck MacMahon, one of the Excelsior park managers, placed a call to the fire department after seeing the flames coming out of the ballroom. The fire department arrived on the scene at the ballroom in a matter of minutes, but it was already too late. Made mostly of old wood, Danceland was quickly consumed in the fire. The fire department poured water at full blast on the building, but according to Fire Chief Lebahn Morse that day, "With a building that size, totally involved, no amount of water can faze it much." Twenty-eight firemen from

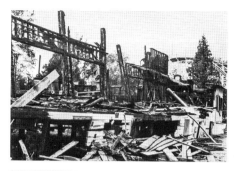

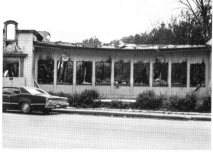

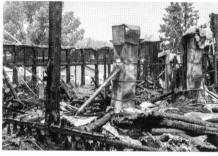

Above, left: A rear view of the ashes from the Danceland fire. *Pearce Family Photographs, used with permission.*

Above, right: A view of the Danceland ruins from the front. *Pearce Family Photographs, used with permission.*

Left: A close-up view of the Danceland ruins after the fire. *Pearce Family Photographs, used with permission.*

Excelsior were at the scene working three water pump trucks and a tanker. A small crew of Excelsior firemen remained on the scene for the entire day, continuing to put water on the smoldering ruins.

The Minnetonka Fire Department helped fight the fire with a pump truck and a rescue squad, and nearby Mound Fire Department was on call at the Excelsior station in case another fire call came to the station. Only one firefighter, Robert Bossert Jr. of Excelsior, was injured in the battle with the blaze. He was treated for a cut to his head that required seven stitches at Methodist Hospital and was released. The Minnesota Highway Patrol had to close the overpass leading from Highway 7 to Excelsior during the height of the blaze due to the sparks and heat emanating from the fire. Fire Chief Morse said, "Fortunately the wind wasn't blowing toward the amusement park. Then we would have had a real problem." Park owner Fred Pearce reported that some old cash registers and a quantity of plywood was stored in the ballroom's old basement. Since 1967, the building had been leased by the Excelsior Boat and Motor Mart.

Jeffrey Malloy Williams, twenty-four, of Long Lake was arrested later that Sunday night by the local police in connection with the fire and charged with arson. Others were suspected in the arson. The complaint filed against Williams alleged that, "aided and abetted" by other persons, he set fire to Danceland. It alleged that there was a gathering of "kids" prior to the fire,

Left: Gas can found in the Danceland ashes after the fire. *Pearce Family Photographs, used with permission.*

Below, left: Looking through the Danceland ashes to the park's roller coaster across the street. *Pearce Family Photographs, used with permission.*

Below, right: An overview of the Danceland ashes the day after the fire. *Pearce Family Photographs, used with permission.*

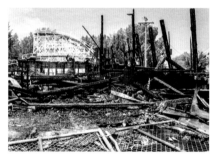

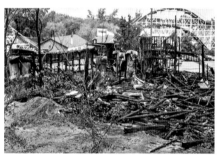

that Williams was observed near the building with an empty gasoline can in his hand and that he said that the building was going to be burned down. Williams was charged the following Tuesday morning with simple arson at the Hennepin County Court.

The blaze caused damage in excess of $100,000 to equipment that had been stored within the hall by the Excelsior Boat and Motor Mart. Thirty-eight boats, forty-seven snowmobiles, boat motors, trailers and related boat equipment were destroyed by the fire. Just like that, the existence of Danceland went up in smoke.

FROM THE 1960s TO
THE GRAND FINALE

During this time in the outdoor amusement industry, Six Flags Over Texas had just opened up in August 1961, and its early success was the amusement industry's first sign that the outcome of Disneyland's vision was an industry revolution. The park's founder had visited Disneyland in the late 1950s, and he thought he could offer the same family fun that Disneyland offered but in a more exciting way and closer to home. He employed the services of R. Duell and Associates, a California architectural firm that specialized in the design of theme parks that merged traditional architecture with staging. One of the principals at the firm, Randall Duell, had previously worked as an art director at MGM Studios. After Duell's departure from MGM in 1959, he joined Marco Engineering, a group of theme park developers and designers, most of whom had worked at Disneyland. During Duell's short time at Marco, he gained a further appreciation of the merging of architecture, set design and theme park construction in his work at Marco as a co-designer of theme parks. The following year, Duell left Marco Engineering to establish R. Duell and Associates.

During this time, operations and marketing practices at Excelsior Park continued much as they had in the past. One of the more unique marketing concepts occurred in 1962, when radio station WDGY disc jockey Terry Rose rode the Excelsior Park roller coaster for three hours and twenty-one minutes straight. During his ride, Rose ate three hot dogs and lost both his tie clip and seven pounds. Rose's thirty-five-mile promotional stint was a part of WDGY's High School fun day at the park that year.

Excelsior Park's embrace of the television industry continued through the 1950s and into the early 1960s, as the park hosted and then later named the Funhouse after Axel Torgeson, a popular television character known throughout the Upper Midwest because of his own television show on WCCO. Axel was played by Clellan Card, a well-known radio and later television personality who lived in Excelsior. The Axel character was a loony "Scandihoovian," created by Clellan in the late 1930s as a part of a morning show on WCCO AM radio called *Almanac of the Air*. Axel's live event at Excelsior in 1958 generated an attendance of twelve thousand people.

Axel would make occasional appearances at the park, and publicity shots would show him driving the hot rods or hanging out near Axel's Laff House. A photo taken of Axel in June 1964 shows Axel, appearing in front of [the] Axel's Laff House, handing the first set of tickets for his "Free Ride for Good Students" month. Starting June 5 of that year and lasting through July 3, children who turned in their report cards to the park received four ride tickets for each A grade and two ride tickets for a B grade or equivalent on academic subjects. More than eleven thousand students participated in the promotion in 1963.

In November 1962, Fred Pearce Jr. was elected the first vice-president of the National Association of Amusement Parks at the association's annual November meeting in Chicago. Pearce was a former director, officer and program chairman for the association.

For the 1963 season, Excelsior introduced three new rides: Jungleland, a soaring Flying Coaster and Swinging Cages. Jungleland was a remodeled version of the Pretzel dark ride.

For the park's fortieth anniversary in 1965, the park added another three new rides: the Bubble Bounce, the Paratrooper and the Trabant. By then, the park was hosting company picnics for many of the large Twin Cities companies such as Honeywell, General Mills, Northern States Power Company, Northwest Airlines, Northwestern Bell and Minneapolis Gas, to name a few. The park in 1965 consisted of seventeen acres. Also for the

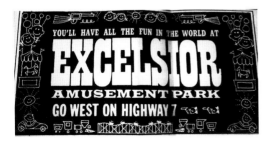

Promotional sign for the park. *Author's photo with permission from the Excelsior–Lake Minnetonka Historical Society.*

fortieth anniversary, the Silver Dollar Café received a new turn-of-the-century motif. The diner's menu was enlarged for this season; in addition to the American favorite foods of hot dogs and hamburgers, the café started serving fried chicken, corned beef and box lunches for boaters who regularly used the docking facilities at the park. At the time of the anniversary, the park had seven acres of parking and employed about 130 people.

Meanwhile, design work on a second Six Flags park near Atlanta, Georgia, began in 1963, and the park, Six Flags Over Georgia, opened for business in the spring of 1967. When this park opened, Six Flags became the first multi-facility theme park company in America. Soon Six Flags began construction of its third park, to be located outside St. Louis. The success of Six Flags really opened the eyes of the other amusement park operators to the profitability of the new type of outdoor entertainment that began with Disneyland.

Near the end of the 1967 season, Excelsior dismantled its smaller Ferris wheel, which it had been operating for more than twenty years, as well as the Bubble Bounce. It retained the new, larger Ferris wheel that the park erected on Labor Day 1967. This dismantling gave the park an early start to its 1968 season. One of several additions for the season included tearing out the west end of the old Dodgem building and enlarging that side of the building to accommodate newer bumper cars for the next season. The new bumper cars were set to be riding around on a brand-new, all-steel floor fastened down with more than five thousand screws. A new recessed ceiling was built for the ride's lighting system.

Due to safety regulations, all the cars for the roller coaster had to be completely rebuilt in 1968, with only the trim and basic frames of the originals remaining. The park had obtained a second set of cars and many new parts when Wildwood closed, so even the iron wheels were new. The general appearance of the coaster trains was the same, except that safety bars had been added. The roller coaster structure was repainted for the season, and the entrance lettering was redone.

Chuck MacMahon, the son of Ethel and grandson of Fred Pearce Sr., came to work full time at Excelsior Park in 1969 after having returned from Vietnam and Cuba, completing his active-duty service in the Navy Seabees. Chuck was not the first male in the family to serve in the navy, as that honor belonged to Chuck's uncle, Fred, who was operating the park. In fact, water has been a pretty central theme to the Pearce family ever since Josiah's work at Cunard. Many of the roller coasters and parks built by the Pearce family were located alongside oceans, lakes or rivers, and most

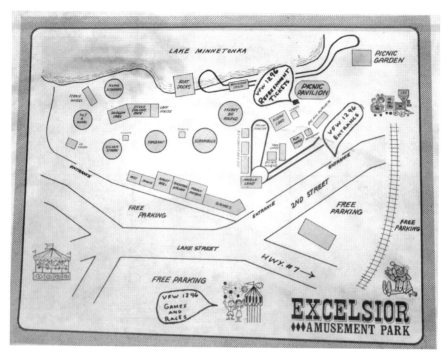

A hand-drawn map depicting the park and its attractions sometime after 1957. *Author's photo with permission from the Excelsior–Lake Minnetonka Historical Society.*

A five-year-old Chuck MacMahon at the helm of one of his grandpa's speedboats at Walled Lake, Michigan. *Pearce Family Photographs, used with permission.*

Chuck MacMahon and his uncle, Fred Pearce Jr. *Pearce Family Photographs, used with permission.*

parks or rides included some form of speedboat entertainment for the park guests. Fred Pearce Sr. took to naming the boats at his company's parks after family members. Chuck relocated his residence from Bloomfield Hills, Michigan, to Excelsior after taking on the job at the park. MacMahon's Excelsior residence was initially a rented room not far from the park, just a few blocks away. For a short time, he, too, resided in the small apartment that Fred Jr. utilized. In the last years of the park, Chuck moved to the Bayshore Apartments, which was located at the end of the park property. This unit was a rental complex that Fred Jr. had constructed.

By the time he arrived in Excelsior, Chuck MacMahon had a variety of experience in the amusement industry. He had worked at both Walled Lake in Michigan and Excelsior Park. During his early years, he did an endless variety of jobs. Very often, though, he could be found in the office. A big task he was involved with doing was the physical counting of money, as operating an amusement park back then was nearly an all-cash operation. Dollar bills and coins needed to be sorted and then wrapped for deposit at the bank. The job was time-consuming and a little dirty. He also had to compile and complete the various accounting forms the company used for each of the

various entities, games, rides and so on. It was all manual, and the numbers had to balance, which often required a great deal of checking to find the smallest error. He had also worked the live shooting gallery, loading the live .22-caliber bullets into brass tubes of the rifles. He also manually counted the ride tickets so operations would know the gross take from each ride as well. MacMahon also had operated a few of the games (such as the balloon dart game) at times to give the game operator a break. He found that the shooting gallery was particularly noisy, with the continuous *plunk plunk* sound as the bullets struck the metal targets.

As it was the top producing ride on the midway, Chuck MacMahon had to spend some time learning to brake the trains of the roller coaster, as an operator really needed to develop a touch and feel for the coaster brakes. If done incorrectly, the metal-to-metal braking system could "stick" the train to the brakes, and it was quite a task to break the train free—and that task needed to be performed by those who were operating the ride. Rainy days were also tricky for an operator because the braking system would get wet, making it difficult to stop the momentum of the coaster train. Sometimes passengers would unintentionally get a second ride for free. Learning to walk the carrousel to collect tickets was another task for which he was trained. The operator had to look for the one red light on the running board—that is where the operator would begin taking the tickets from the riders. Chuck also had learned how to balance the Ferris wheel when loading and unloading passengers. The wheel was driven by a flat belt, so an operator needed to use caution with the drive system to ensure that the drive belt stayed center line on the drive wheel. Many times, a ride owner would dress the wheels to get the flat belt to stay center line. The clutches for a Ferris wheel are manual, and each wheel took a bit of a learning curve.

At the time MacMahon joined management, as he explained it, there was not really a defined management title at the park. He said that as he spent more time at the park, he began to assume more and more of the day-to-day management. Some of his duties as park manager included handling the picnic bookings; assisting in the accounting of the general operations, such as money counting and bank deposits; maintaining ride operations and maintenance; overseeing advertising and a variety of promotions; and overseeing the management of a commercial car wash and gas station that the Pearce company had built on nearby property.

Excelsior Park constructed a new restaurant in 1969 near the site of the once-famous Blue Line Restaurant, which had been destroyed by fire in the late '40s.

Children enjoying the park's Eli Bridge Ferris wheel. *Western Hennepin County Pioneer Association, Long Lake, M.N, used with permission.*

The park had a fairly good relationship with the town, according to Chuck. Excelsior Park always employed quite a few local residents and brought a good deal of business and attention to the town. Chuck recalled that at peak times the park would employ upward of 110 people, and the concessionaires would have additional workers from the city. Excelsior Amusement Park was the largest taxpayer, employer and business in Excelsior.

On August 23, 1971, the Excelsior City Council ordered the "Boatworks Project," a sewer improvement located in Second Street and County Road 82. The improvement was an extension and addition to the Metro Sewer project then under construction. The assessment that was initially charged

Ride tickets from Excelsior Amusement Park. *Author's photo with permission from the Excelsior–Lake Minnetonka Historical Society.*

to Excelsior Park was $10,600, with an additional $4,400 for the second parcel located across the street that used to have Danceland and parking. The park fought the sewer assessment on both parcels and brought a lawsuit that was heard in Hennepin County District Court. Just before the Fourth of July 1973, the court decided to rescind the assessment on the park but upheld the assessment on the other parcel. Might this assessment have been the reason why the park would soon cease operations? Probably not entirely, but I'm sure it had to remind park management of the ramifications of taxes on the property and the high cost needed to upgrade park infrastructure.

If nothing else, it appears that the Boatworks Project may have kick-started management's review of options for the Excelsior Park property. Sometime during the winter of 1971 and into 1972, Fred Pearce Jr. initiated conversations with IDS Properties, which had just finished building the IDS Center in downtown Minneapolis and was not involved on a real estate project at the time. IDS—through IDS Center project managers Vice-President David Sherman and Walter Wittmer—and Fred Pearce contacted a former vice-president of Six Flags who had recently formed his own company, Leisure and Recreation Concepts (also known as LARC), to perform a feasibility study on Excelsior Park. Fred Pearce Jr. wanted to know if it was economically feasible for the park to add other major thrill rides to continue to drive attendance to Excelsior Park. After all, the park had a limited footprint and was inadequately situated to facilitate a larger number of cars. Also, the City of Excelsior was not particularly doing the park any favors as far as finding parking places or offering an agreement on shoreline taxes. After the study confirmed that the park as currently configured would not be able to accommodate the number of vehicles or space necessary to support more major rides at the park's current location in Excelsior, Pearce Jr. reached the conclusion that the company needed to look for land that would support a park with more major rides.

During this time, IDS Properties had been developing real estate parcels on the Minnesota River east of Shakopee. Heading up this development was David Sherman. All of the development of the property was spoken for except for 235 acres of property near a bend of the Minnesota River. Now, Sherman did not have any background in the amusement industry, but he was able to put together that the remaining land in the Shakopee development might be a suitable fit for the type of modern theme park that Fred Pearce had outlined during the feasibility studies Pearce had performed with IDS. In fact, Pearce admitted that the prospect of modernizing Excelsior Amusement Park was a "very heavy investment" he avoided. "The park was old," Pearce said, and "it was badly lacking parking." Due to its location, Excelsior Park had inadequate land to support a theme park. According to Chuck MacMahon, he and Fred Pearce looked at a variety of properties for a future park and spent a great deal of time reviewing its ultimate location and physical configuration. They would rent airplanes for aerial views and then physically drive around the properties. The conversations between David Sherman, Walt Wittmer and Fred Pearce continued into the summer of 1972. Wittmer and Sherman put together a business plan for a new park in the Twin Cities and presented it to the IDS board of directors in New York a total of three times, but they were rejected every time. Sherman and Wittmer became so committed to the project that they soon resigned their positions with IDS and wanted to go forward with the plan for a theme park at Valley Park in Shakopee.

On the front page of the October 4, 1972 *Maverick* newspaper, the headline told it all: "Owner Plans to Close Excelsior Amusement Park, Build Multi-Million Dollar Entertainment Complex Along Minnesota River in Shakopee." By that time, David Sherman and his group, including Fred Pearce Jr., had submitted plans to the Shakopee government agencies for a "themed family entertainment center" in Shakopee on a 235-acre site in Valley Park. This entertainment center would include an amusement park themed as an early 1900s trolley town, a restaurant, a marina on the Minnesota River, a campground and a hotel, with an investment of $4 million. Themes for the new Shakopee site included "turn of the century," "modern day" and "seacoast," while a marina, a campground, horseback riding and other outdoor family activities were also included. The proposal included an application for the property to be rezoned from I-1 (industrial) to B-1 (business), which already had been submitted to the Shakopee planning commission. Once the rezoning was granted, Fred Pearce and Dave Sherman hoped that construction could begin in 1973. At the time of

the announcement of this themed family entertainment center, plans for the disposition or conversion of the Excelsior property were indefinite, but Fred Pearce said that he envisioned housing and possibly a restaurant.

According to an article in the *Minneapolis Star* in 1973 written about Henry Gralow, the operator of the Excelsior Park's carrousel, if the Excelsior City Council would not approve the plans for the development of the Excelsior Park property, Fred Pearce stated that he would scrap the plans and the park would be operating the next summer. This reasoning would explain why the auction for the park was held around the midsummer of 1974.

As for whether Excelsior Park was making a profit in its final years, the business was a closely held family operation, and success was not measured entirely in terms of a profit or loss. In fact, the park's final season was one of the best years financially, according to Chuck MacMahon. There was no desperation on the part of the company's business to close and sell the park.

The park was visited, on the average, by 350,000 a year, and it was a profitable operation. Promotions played a key role in helping Excelsior survive the Depression. It used skydivers, a man shot out of a cannon, high-wire acts and radio shows to bring people to the park. Excelsior Park also

Fred Pearce Jr. and Chuck MacMahon examine a carrousel horse prior to the park's last operating season in 1973. *Pearce Family Photographs, used with permission.*

Excelsior's Picnic Headquarters are ideally suited to a family get-together or organization outing. The picnic Garden provides a shelter area for serving ample tables in a shaded grove. The Tonka Garden is a covered picnic pavilion complete with stoves and picnic tables. An outdoor picnic area, snack bar and parking lot are adjacent. A letter or call will bring our immediate attention.

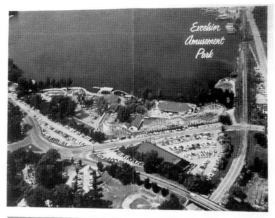

Excelsior
Amusement
Park

Wild animals of Borneo in the Jungleland at Excelsior are guaranteed to thrill young and old.

Excelsior Park is convenient to Minneapolis, St. Paul and neighboring towns. By car from Minneapolis, take Highway 7 west to the Park. From St. Paul, take Highway 494 west, to Highway 7, then west on Highway 7 (see map on back). Buses run direct to Excelsior from Minneapolis on frequent schedules. Or charter service can be arranged by Park personnel from the metropolitan and suburban areas of both St. Paul and Minneapolis.

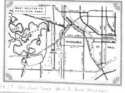

BEST ROUTES TO
EXCELSIOR PARK

MINNEAPOLIS

ST. PAUL

EXCELSIOR PARK

THE NORTHWEST'S LARGEST FUN SPOT
P.O. Box 6, Excelsior, Minnesota 55331
Phone 474-5454 Area Code 612

The front view of a later Excelsior Park brochure, as demonstrated by the train turnaround jutting out from the lakeshore. *Author's photo with permission from the Excelsior–Lake Minnetonka Historical Society.*

Exciting! Unusual! Thrilling! That's Excelsior Park for young and old alike. Bring your children and enjoy watching them have a thrill-of-a-lifetime . . . or come with your friends and re-live your own childhood. Excelsior is famous for fun and frolic . . . for the young and the young-at-heart!

Excelsior has been the favorite fun spot of the Northwest for over 40 years. Every fun filled acre is designed for your entertainment, comfort and convenience. It's the Northwest's largest amusement park . . . and the perfect picnic spot for all!

VISIT KIDDIELAND! One section of Excelsior is set aside exclusively for youngsters. Your children will have a barrel of fun on the Kiddie Whip, Kiddie Autos, Merry-Go-Round, Kiddie Boats and many more exciting attractions. Mom and Dad . . . Grandpa and Grandma, too, will thoroughly enjoy Excelsior's Kiddieland.

TOUR THE MIDWAY! Ride the Midwest's highest Roller Coaster, and old-fashioned Merry-Go-Round, a giant Ferris Wheel and many more fun filled rides. Test your skill at the Shooting Gallery and Penny Arcade. Relax by the cooling waters of beautiful Lake Minnetonka . . . and refresh yourself at the restaurant, garden patio or one of six conveniently-located refreshment centers.

JOIN IN GROUP FUN! If you prefer group activity, Excelsior provides a well-maintained ball diamond, a Teen-Age Danceland and complete indoor/outdoor picnic facilities. The Excelsior staff is trained and experienced to anticipate your needs and provide the conveniences to help make your outing a success.

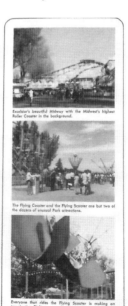

Excelsior's beautiful Midway with the Midwest's highest Roller Coaster in the background.

The Flying Coaster and the Flying Scooter are but two of the dozens of unusual Park attractions.

Everyone that rides the Flying Scooter is making an imaginative flight to unexplored planets.

It's hard to say just WHO has more fun at Excelsior . . . youngsters, teenagers, parents or grandparents. If you're going — as per young-at-heart — Excelsior provides fun unlimited. But the best way to appreciate the completeness of Excelsior's facilities is to see them. Why don't you visit us soon . . . today, perhaps?

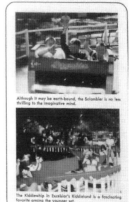

Although it may be earth-bound, the Scrambler is no less thrilling to the imaginative mind.

The Kiddiewhip in Excelsior's Kiddieland is a fascinating favorite among the younger set.

The back side of a park brochure from the 1960s. *Author's photo with permission from the Excelsior–Lake Minnetonka Historical Society.*

Promotional material from the park's final operating season. *Author's photo with permission from the Excelsior–Lake Minnetonka Historical Society.*

had reduced rates for class outings for the local schools to encourage the children to come to the park. More than twenty thousand schoolchildren visited the park each year. For Father's Day on June 19, 1960, Excelsior Park handed out cigars to the first five hundred fathers who visited on that day. The park each year sponsored fireworks during the Fourth of July and Labor Day. The attendance during these days averaged twenty-five to thirty thousand, with an additional one thousand boats parked in Excelsior Bay to watch the fireworks.

The park's marketing message for that last season centered on "Our Farewell Season." Remnants of that marketing plan exist in a scrapbook located in the archives of the Excelsior–Lake Minnetonka Historical Society. The scrapbook outlines the important events that the park hosted during its final season.

But the fun-seekers were few and far between as Excelsior Amusement Park closed on Sunday, September 16, 1973. The weather that day was chilly. That final season of Excelsior Park began on May 12, and due to demand and nice weather, it was extended beyond Labor Day weekend. Chuck MacMahon, the park manager at that time, said that the land occupied by the park could be better used and that it probably would be used for high-density housing such as condominiums. Taxes and land values were getting much too high to continue using the land as an amusement park, said MacMahon at the time. Fred Pearce Jr. noted that although the amusement business had been in his blood all his life, he had to face the economic facts that he lacked the land for further expansion of Excelsior Park. Without expansion, it would not be economically feasible to modernize the park into a first-class amusement park.

WHAT HAPPENED WITH THE PARK PROPERTY AND THE RIDES AFTER THE PARK CLOSED?

In July 1973, during the park's final year, E&F Development Company proposed condominiums and a restaurant totaling more than $10 million to replace some of the land on which Excelsior Park resided. This plan sought to fill one of the four parcels that the Excelsior Park Company owned. The parcel about which this proposal was made was 8.6 acres of the 16.5 acres owned by the former park's owner. While Pearce's initial plans for the use of the property were amended and modified, eventually condominiums and a restaurant were built there.

Knowing that the proposed development was acceptable to the city, the physical structures of Excelsior Park began to be torn down starting in May 1974. A number of the park's structures were disassembled by Joe Gloccum & Sons, and by July 1, 1974, the park's roller coaster was a third of the way dismantled.

On June 14, 1974, a proposal to transport the Ferris wheel and seven other amusement rides from the defunct Excelsior Amusement Park resulted in a strong protest by the residents of Ham Lake, Minnesota. Former Excelsior Amusement Park manager Chuck MacMahon and his business partner proposed a family entertainment center (FEC) on a 110-acre of farmland in central Anoka County that would incorporate those eight rides from Excelsior Park. The proposed FEC was to be closed to the general public and to be marketed to organized groups like church groups or businesses with 1,000 to 1,500 employees.

However, 343 persons signed a petition protesting the plan. Protestors claimed that the traffic, the noise and the sewage would be too much for the community to handle. The site, located on the east side of Ham Lake and north of the Baptist, had about 1,200 feet of lakeshore. According to city officials, the proposal included plans for a "serene country farm atmosphere" with a small petting zoo of barnyard animals, sports fields, playground equipment, hay rides and pontoon boat rides around Ham Lake. City officials were told that the park would operate during daylight hours of June through August, and the proposed owners planned to apply for a 3.2 beer license.

The business partners went as far as to have preliminary site plans and design sketches completed. The idea, however, never advanced to full-scale construction design and plans. While the partners were poised to move to that next phase, including a presentation to the local community that would have required its support for the necessary zoning changes and permits, the project did not move forward. There was not enough time, with an auction scheduled in another month, to properly develop the park proposal together with securing the necessary financing.

A ticket booth from the park has been preserved and can be found in front of the Excelsior–Lake Minnetonka Historical Society Museum. *Author's private collection.*

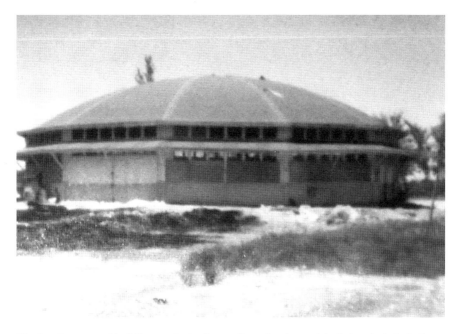

The lonely carrousel building awaits its dismantling after the park had closed. *Author's photo with permission from the Excelsior–Lake Minnetonka Historical Society.*

The auction of Excelsior Amusement Park items was scheduled for Saturday, July 24, 1974. Fred Pearce Jr. described the auction at his park as "sort of like picking the bones." The auction began at 9:30 a.m. About 2,000 people invaded the park to bid on everything from ice cream scoops to roller coaster cars. Of those people, 831 people bought auction tickets. Anything that was bought that day had to be hauled away by the end of the next day, Sunday, July 25. Checks were accepted at the auction but only with a letter of credit. The large items such as the pavilion, the carrousel building and picnic shelter failed to sell at the auction, as most attendees were looking for memorabilia of the park.

At 9:30 a.m., the antiques were auctioned off, including the following: one hundred bentwood chairs, three ice cream coolers, a popcorn stand, wooden milk bottle bins and a streetcar heater. The restaurant equipment was auctioned at 9:45 a.m. A Scotsman ice shaver, a twenty-gallon stew pot, some hot dog cookers and a cotton candy machine were just some of the restaurant items auctioned. The auction for the miniature train, the shooting gallery, an English cab and the kiddie boat ride began at 12:30 p.m. Among some of the items sold at the auction were six roller coaster cars at $65.00

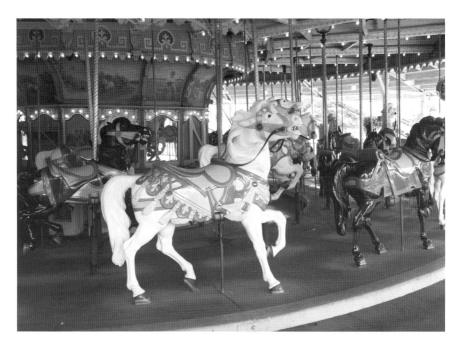

A carrousel horse as it exists at Valleyfair Amusement Park in Shakopee. *Author's private collection.*

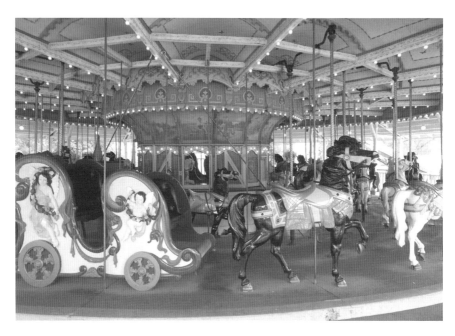

A beautiful hand-carved chariot that is a part of Philadelphia Toboggan Company carrousel no. 76, now operating at Valleyfair Amusement Park. *Author's private collection.*

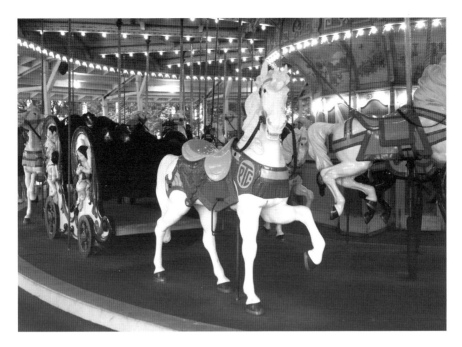

Picture of the lead horse on carrousel no. 76 in its new home. It is known as the lead horse because of the PTC shield prominently displayed on the horse. *Author's private collection.*

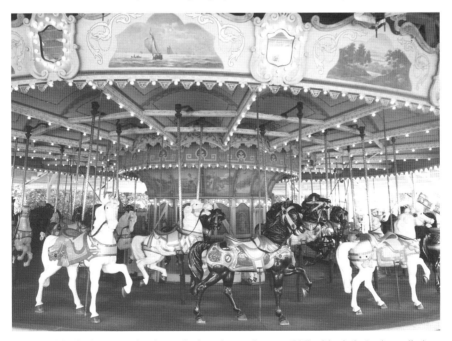

The Excelsior Park carrousel as it now looks at its new home at Valleyfair. *Author's private collection.*

apiece, a beer tap for $360.00, a pinball machine for $100.00, a step ladder for $1.00 and a waste basket for $0.50.

It wasn't a happy day for Pearce as he watched his park being hauled away bit by bit. The amusement park had been in his family for forty-eight years, and it was much like the feeling one has when moving to a new house. However, Fred and the rest of his family should remember that Excelsior Amusement Park will remain, although scattered, in the homes and the backyards of the people of Minnesota.

By March 1976, workers were already busy disassembling the carrousel building on the former park's property. International Multifoods had plans to build a restaurant on the site of the old carrousel building and was planning to just demolish it, but at the last minute, an anonymous woman from Victoria wanted the building. That lady was later revealed to be Grace Lindley. The reason she wanted the building was because she thought it was "such a beautiful building." Bolt by bolt, the carrousel building was taken apart by workers for Lunak Construction. International Multifoods acquired the property from Rauenhorst to build a T Butcherblock restaurant, and since it wanted the building gone, International Multifoods just gave the building away. Grace Lindley owned Victoria Farms in Victoria and included the carrousel building at the horse farm to house an antique carrousel inside, as well as operate as a machine shed. The carrousel building was demolished in 1988 along with the other building at Victoria Farms to make room for the Deer Run golf course when the farm was sold.

By 1978, parcel after parcel of land that comprised Excelsior Amusement Park was being snatched up by developers willing to pay a premium price for commercial property located on or next to Lake Minnetonka. In 1977, a Polynesian restaurant was built on the land that was the far corner of the park, near where the Funhouse and part of the coaster used to be. Fred Pearce Jr. was one of these land developers.

As for the new "themed family entertainment center" located in Shakopee's Valley Park, after several bumps along the way, the modern theme park , named Valleyfair Amusement Park, opened in May 1976. Economic Research Assocation, a firm founded by Buzz Price, the same person who helped pick the site of Disneyland, was a consultant for Valleyfair, and LARC worked on the initial park design. Fred Pearce Jr. became a shareholder and initially sat on the board of directors of Valleyfair. He was very defensive about the new park, which included several of the rides from Excelsior Amusement Park, given a new life

at Valleyfair. The most notable ride was the Philadelphia Toboggan Company–manufactured hand-carved wooden carrousel. The carrousel took a place of prominence near the entrance to Valleyfair, and its band organ still beckons one and all into the park to have fun. Other rides that found a new home at Valleyfair included the Flying Scooters, which was located near the new wooden roller coaster, High Roller; the Scrambler; and several of the kiddie rides. The management of Valleyfair decided that instead of allowing Fred to place the rides at the park, much like a concessionaire, they decided to pay Fred Pearce a fair price to purchase the ride equipment that ran at Excelsior. Due to this arrangement, the Valleyfair partners had to enter the carrousel building and disassemble the carrousel in the middle of the night. The new park's management had to hide the individual carrousel horses in various locations throughout the Twin Cities so that the horses would not be held hostage by people in the Excelsior area who did not want to see the carrousel move from Excelsior.

After the 1978 season, Valleyfair management was searching for additional investors to expand the park and capitalize on its success, and park operator Cedar Point Inc. from Sandusky, Ohio, was looking for a place to invest its

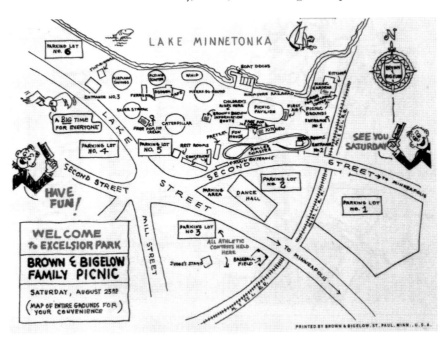

Ad used by Brown & Bigelow for its company picnic at the park. *Author's photo with permission from the Excelsior–Lake Minnetonka Historical Society.*

cash to avoid becoming a take-over candidate, so Cedar Point bought out the Valleyfair investors. With the buyout, Dave Sherman left the park business, Walter Wittmer stayed on as a part of the park's management team until 2001 and Fred Pearce Jr. no longer maintained a relationship with an amusement park in Minnesota. After more than forty years, Valleyfair stands today as a reminder to the residents of Minnesota that a number of those memories made at Excelsior Park can be found and relived even today.

BIBLIOGRAPHY

Books

Anderson, Norman D. *Ferris Wheel: An Illustrated History.* Bowling Green, OH: Bowling Green State University Popular Press, 1992.

Bush, Lee O., and Richard F. Hershey. *Conneaut Lake Park the First 100 Years of Fun.* Fairview Park, OH: Amusement Park Books Inc., 1992.

Cartmell, Robert. *The Incredible Scream Machine: A History of the Roller Coaster.* Bowling Green, OH: Bowling Green State University Popular Press, 1987.

Excelsior Amusement Park promotional scrapbooks. Owned by the Excelsior–Lake Minnetonka Historical Society.

Excelsior–Lake Minnetonka Historical Society. *A Picture Book of the Excelsior Amusement Park…from Rise to Demise 1924–1974.* N.p., 1991.

O'Brien, Tim. *The Essential Guide to Six Flags Theme Parks.* Birmingham, AL: Oxmoor House Inc., 1996.

Price, Harrison "Buzz." *Walt's Revolution by the Numbers.* Orlando, FL: Ripley Entertainment, 2003. Quoted extensively with permission from Ripley Entertainment.

Shogran, Rudy S. Yearly diary. Owned by the Excelsior–Lake Minnetonka Historical Society.

Magazines and Newspapers

American Museum of Public Recreation. Brochure, circa 1931.

Billboard. December 4, 1924; June 14, 1931; July 15, 1933; August 9, 1941; July 10, 1943; August 21, 1943; March 18, 1944; August 10, 1946; August 17, 1946; February 7, 1948; October 9, 1948; January 22, 1949; June 25, 1949; July 30, 1949; May 10, 1952; September 6, 1952; July 18, 1953; August 4, 1956; August 17, 1959; September 19, 1960. Cincinnati, OH, and New York, NY, 1902–1976.

East Side Argus. February 23, 1925.

Hennepin County Review. August 26, 1937.

Johnson, Walter. "Owner Plans to Close Excelsior Amusement Park, Build Multi-Million-Dollar Entertainment Complex Along Minnesota River in Shakopee." *The Maverick*, October 4, 1972, 1.

The Maverick. "Fire Destroys Amusement Park Dance Hall, Arrest Made." July 17, 1973, 1.

Minneapolis Daily Times. May 3, 1945.

Minneapolis Journal. June 19, 1933; June 8, 1934; July 28, 1935; July 24, 1938.

Minneapolis Shopping News. August 26, 1937.

Minneapolis Star. "Excelsior Park to Reopen Tonight: Specially for BeBe." September 15, 1948, 36.

——. May 3, 1931; June 6, 1931; July 23, 1931; August 1, 1931; August 26, 1931; August 1, 1932; April 29, 1938; July 21, 1938; August 19, 1942; June 26, 1948; April 19, 1950; February 11, 1958; June 2, 1973; November 24, 1975; June 15, 1976.

Minneapolis Sunday Tribune. June 11, 1950.

Minneapolis Times-Tribune. August 23, 1939.

Minneapolis Tribune. July 31, 1932; September 1, 1933; September 2, 1933; August 21, 1938.

Minnetonka Herald. August 8, 1958.

Minnetonka Record. September 26, 1924, 1; December 12, 1924, January 16, 1925, 1; January 30, 1925, 1; March 20, 1925, 1; April 3, 1925, 1; May 8, 1925, 1; May 22, 1925, 1; April 30, 1926, 1; May 13, 1927, 1; April 20, 1928, 1; August 3, 1928, 1; May 3, 1929, 1; May 15, 1958, 1; October 26, 1961, 1.

Mitzel, Steve. "Walled Lake Park." *NAPHA News* 11, no. 2 (1989).

North Minneapolis Journal. May 10, 1973.

The Shopper's Guide. September 9, 1932.

Star Journal. May 7, 1944.

Stark, George W. "Roller Coaster's Chief Advocate." *Detroit News Magazine*, July 17, 1952.

St. Paul Dispatch. August 10, 1950.

St. Paul Pioneer Press. July 9, 1954.

The Sun. April 17, 1967; April 11, 1968; July 18, 1974, 1; March 17, 1976.

Sunday Journal. June 1925.

TV Guide. July 31, 1954.

Valley News, "Valleyfair: Forty Years of Amusement" May 10, 2016

Interviews

MacMahon, Charles. Interviews by author, September 2011 and periodically since then.

Sherman, Dave. Interview by author, April 15, 2016.

Town, Jayne Clapp. Interview by author, October 26, 2013.

Wittmer, Walt. Interviews by author, October 2013 and November 2016.

Websites Consulted

Lake Minnetonka. "Danceland and Early Rock n' Roll (Part 2)." http://lakeminnetonka.com/about/local-lore/danceland-and-early-rock-n-roll-part-two.

Twin Cities Music Highlights. "The Rolling Stones at Danceland." http://twincitiesmusichighlights.net/rollingstonesatdanceland.

ABOUT THE AUTHOR

Never one to appreciate amusement parks when he was younger, Greg Van Gompel was truly not that interested in amusement parks until he finally relented to join a friend for a weekend event with the National Amusement Park Historical Association (also known as NAPHA) back in 1988. He has been hooked on amusement parks ever since. In 1990, Greg Van Gompel became legal counsel to NAPHA and for about six years was editor of its magazine publication, *NAPHA News*. Combining his thirst of knowledge for historical information together with his passion for the amusement industry, Greg peruses postcard collections, the Internet, libraries, historical societies and industry publications to increase his knowledge on the amusement industry. Occasionally, his family members such as his dad Marcellus, wife Conni or granddaughter Lily join him in his searches. He finds the topic of Excelsior Amusement Park and its owner, Fred Pearce, intriguing and hopes you do as well.

Visit us at
www.historypress.net
...
This title is also available as an e-book